RURAL BARNS

By Randall Branham

No part of this publication may be reproduced, stored in a retrieval system or transmitted in any form or by any means, without written permission from the publisher.

For information regarding permission, write to:

Branham photography

c/o Randall Branham

4910 Potts Hill Rd.

Bainbridge Ohio

45612

Photography by Randall Branham

Photography Copyright © Randall Branham

All Rights reserved.

Published by Randall Branham

Acknowledgments

With all my love, to my devoted wife Kay, I am thankful for her encouragement, support and patience, throughout my photographic endeavors.

To my daughter Tara, while working on her Doctorate of Education Ministries [DEdMin] has constantly motivated, directed and guided me to publish my own book.

To my daughter Nikki, the former Assistant News Editor of the Cincinnati Enquirer has helped me so much in editing and laying out the proper direction to take.

To my son Tony, my expert on computers and CMYK printing algorithms, for all his help and technical advice that I have encountered with computers and color prints.

And to all the friends and family, far too many to name, thanks for all the help and encouragement and my SPECIAL THANKS for all those who are buying Branham Art.

Randall is an International award winning published photographer who has been published in several magazines, *Including Birder's World* and *Over the Back Fence*.

His work is displayed in many galleries, tourist centers, offices, and commercial locations as well as on the walls of customers from coast to coast.

He lives with his wife Kay, also an artist, near Bainbridge, Ohio in the foothills of the Appalachian Mountains where they watch the eagles fly and the deer play.

Contents

BALES AND BARN COLORFUL SUNDOWN ON RT.41 .. 6

ROUND BARN AND BALES ... 7

JAGUAR IN THE BARN .. 8

BARN IN SEPTEMBER AND OCTOBER ... 9

BARN ON SAM'S ROAD .. 10

BICENTENNIAL BARN WITH GOLDENROD ... 11

NEBRASKA FARM ... 12

COCA COLA AND GARAGE .. 13

PATRIOTIC BARN .. 14

YOUNG'S JERSEY FARM .. 15

FALLS CREEK BARN ... 16

MINFORD, OHIO BARN ... 17

SPARGERSVILLE ROAD BARN .. 18

BLUE ICE CHEW MAIL POUCH ... 19

JAG IN THE WINTER BARN .. 20

BLACK CHEW MAIL POUCH BARN .. 21

GERMAN RED TRIM BARN ... 22

SUNSET BARN DRIVE THROUGH .. 23

BARN WITH LONG LANE .. 24

FARM SILOUETTE SUNSET .. 25

GOLDEN SUNSET SURROUNDING BARN ... 26

SLEEPY OLE' BARN .. 27

THE OLE' RANCH .. 28

HOAR FROST BARN .. 29

NOTORIOUS RED BARN IN SMOKY MOUNTAINS .. 30

Contents

OLD AND THE NEW _____ 31

MODIFIED BANK BARN _____ 32

THE RED ROOF ROUND BARN _____ 33

SPRING BRINGS RED GROWTH TO YELLOW Sunset BARN _____ 34

THE BARN AND CORRAL _____ 35

BIG BARN WITH BIG RED SKY _____ 36

BRANHAM FARM BRIDGES, OHIO _____ 37

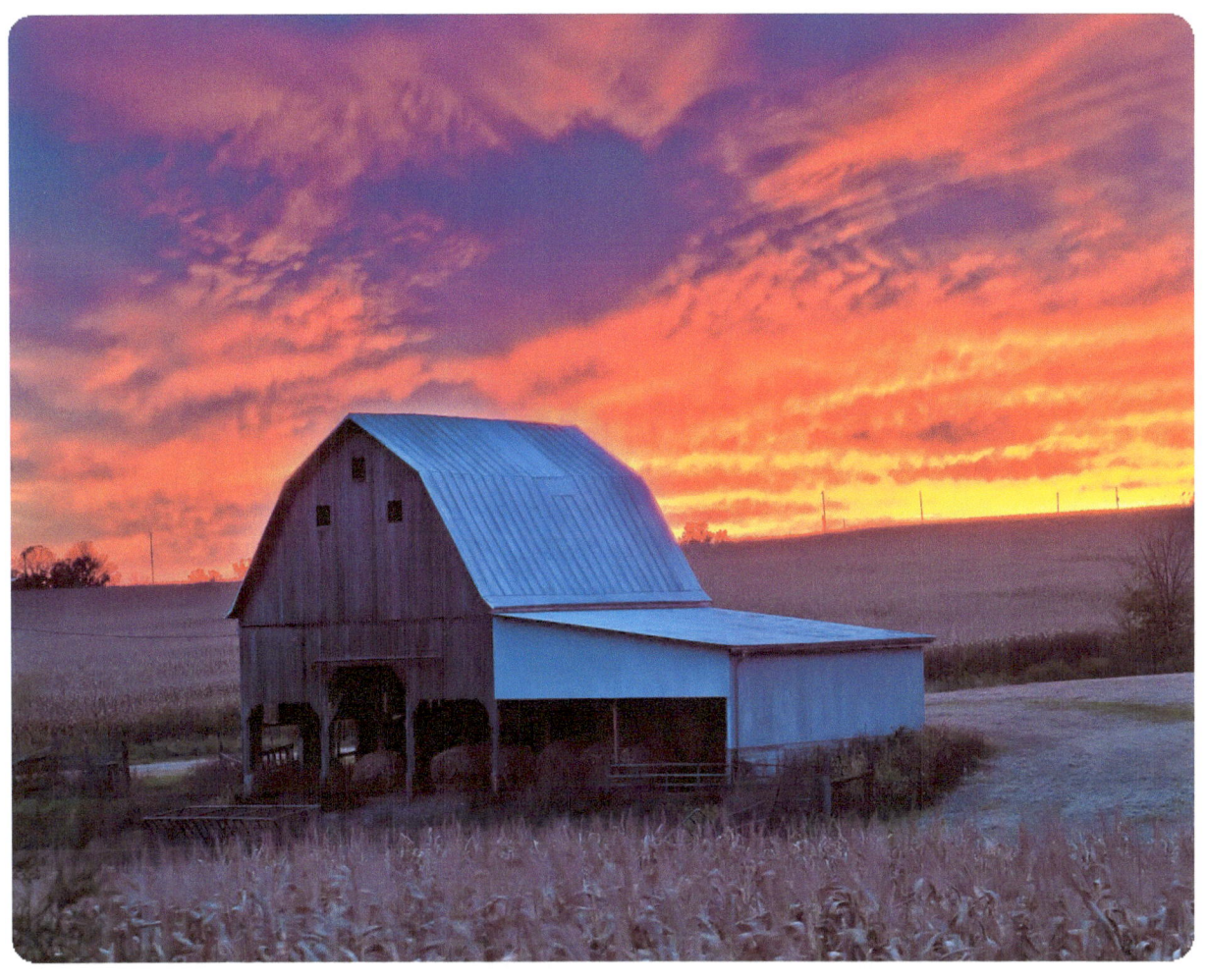

BALES AND BARN COLORFUL SUNDOWN ON RT.41

While driving north one evening, my wife Kay and I were watching a beautiful sunset about to happen. I suggested we look for an interesting foreground subject and capture what was sure to be a colorful sundown. We were not disappointed. We spent the next several minutes photographing some of the most beautiful colors one could imagine. In order to include the detail of the hay in the barn without blowing out the color in the sky, I exposed the camera once for the sky and once again for the bales of hay.

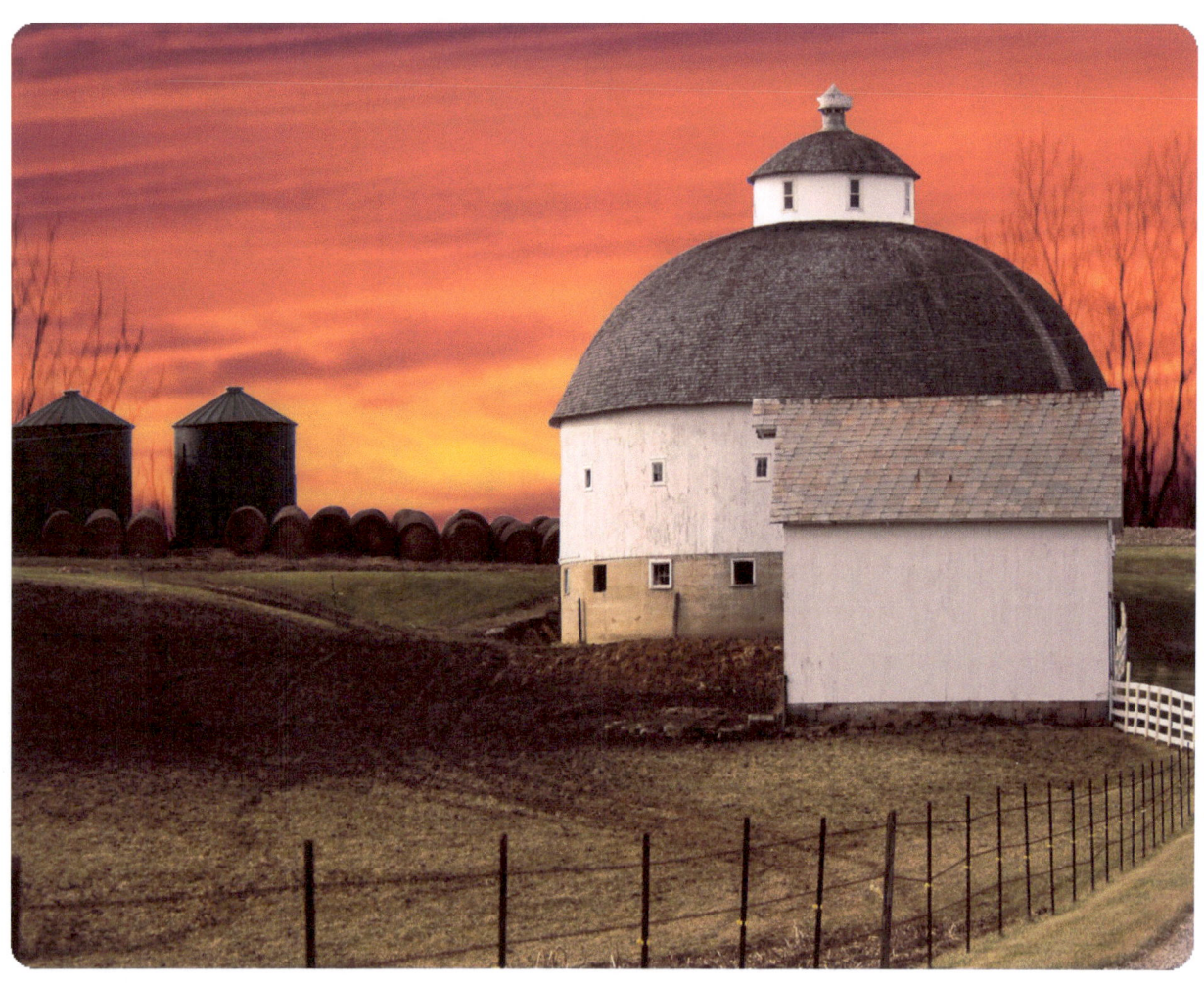

ROUND BARN AND BALES

We were driving up I-70 in the middle of Ohio, when I spotted this big round barn, way off to the left on a side road. The family often calls me "stopthecaroholic" because I often stop the car to grab a moment in time that I know if I don't get it now, I never will. As is often the case, I was right at least with this shot, I came in second place in an International contest of more than 26,000 entries.

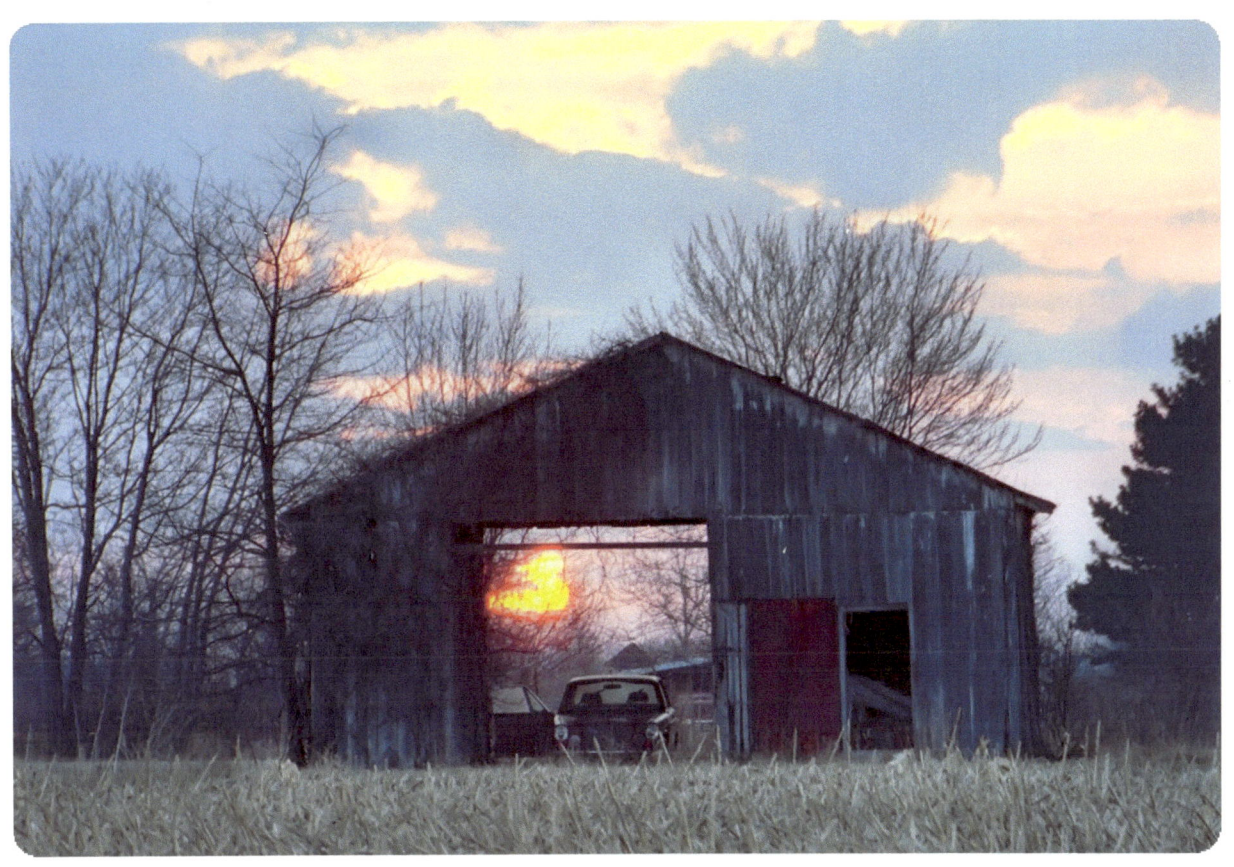

JAGUAR IN THE BARN

We used to live right across National Hwy 40 from this old barn and I just waited until the sun lined up on the right latitude to shine through the barn to capture this image. Unfortunately neither is still there.

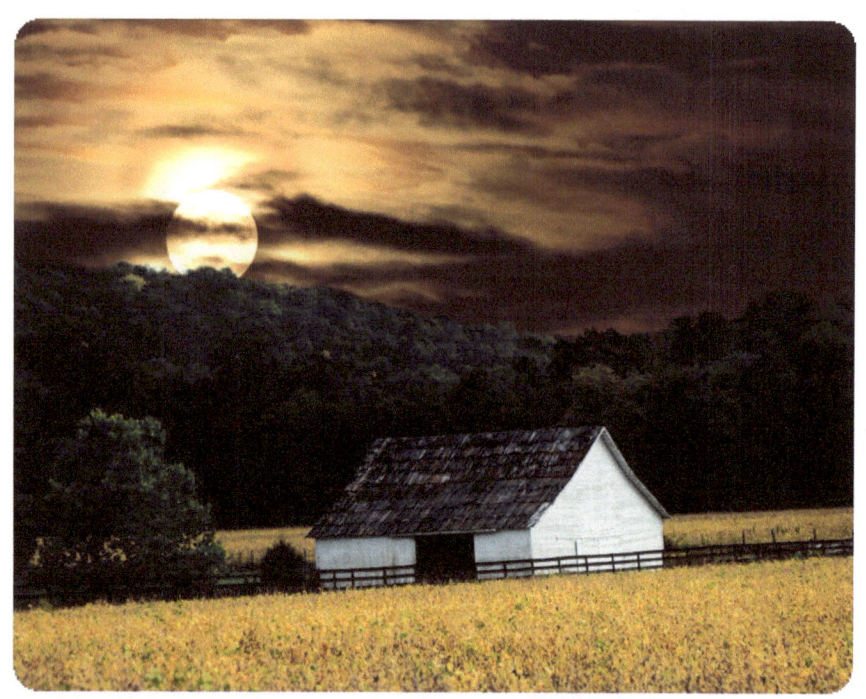

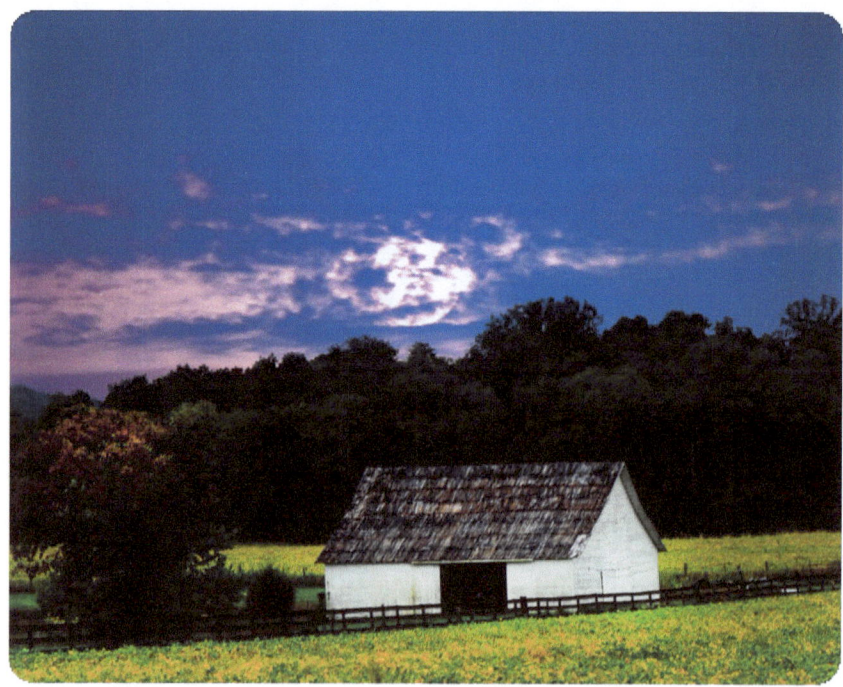

BARNS IN SEPTMBER & OCTOBER

Thirty days makes a big difference. I captured this barn in September and the top image in October. I like the look of this barn with the shake shingle and the black fence running behind the barn. As a teenager, on our farm not far from here, I had the opportunity to reroof our old "bank barn" with wooden shake shingles. It was a lot of work and very high off the ground, two stories high. If you slipped off, you were a goner.

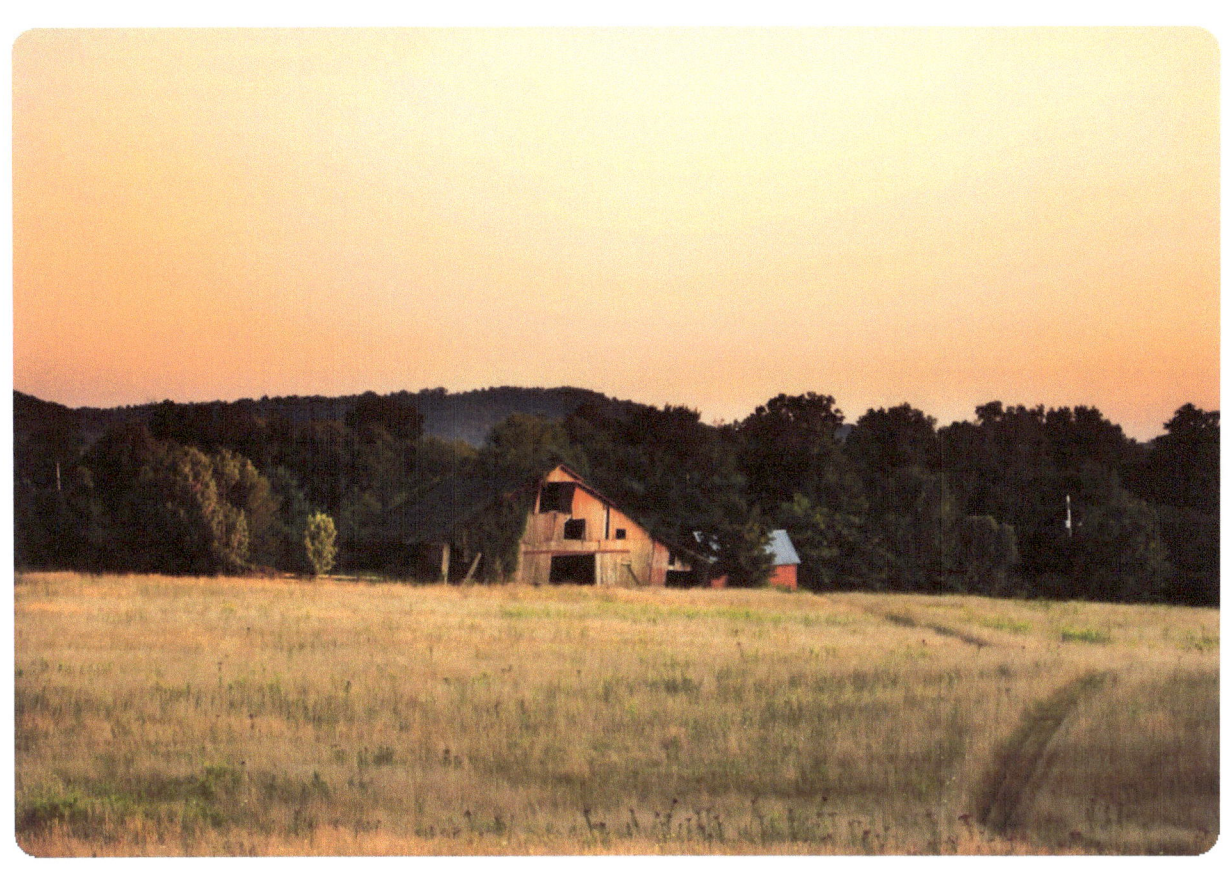

BARN ON SAM'S ROAD

This barn was razed in 2010 – Never could figure that out when we demolish a barn we call it "raze". And why do we "park" on out driveway and "drive" on our parkway. Any way this old barn lived on Sam's Rd. near Rocky Fork Lake in highland County Ohio. My wife Kay has used this photo in one of her oil paintings.

This pretty barn is located in southern Ohio near Minford. We had to drive around the side road and use a telephoto lens of 300mm F/2.8 to isolate the barn from most of the distractions.

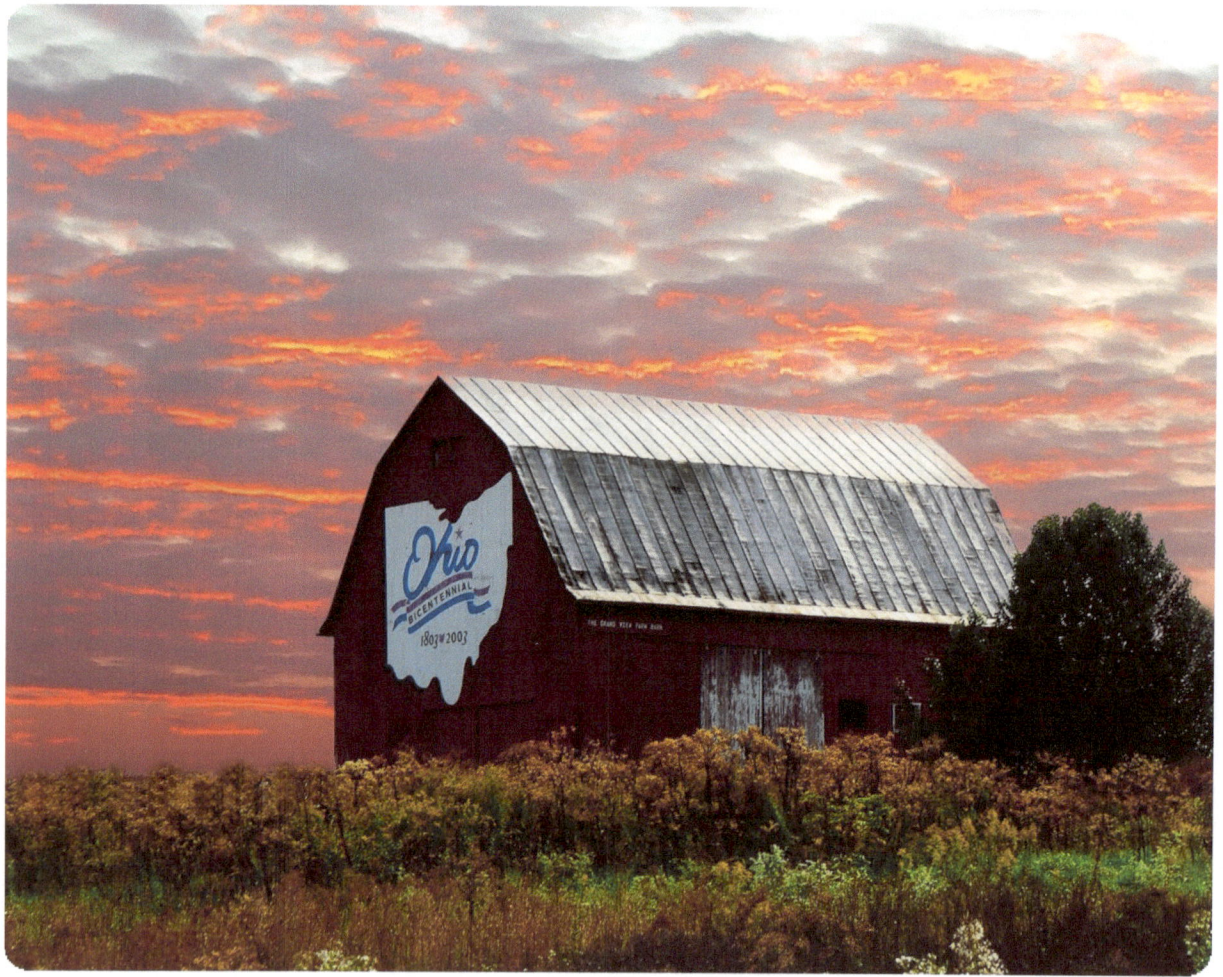

BICENTINENIAL BARN WITH GOLDEN ROD

I have shot this barn a couple of times from different angles, and with the intense sky I like this one best.

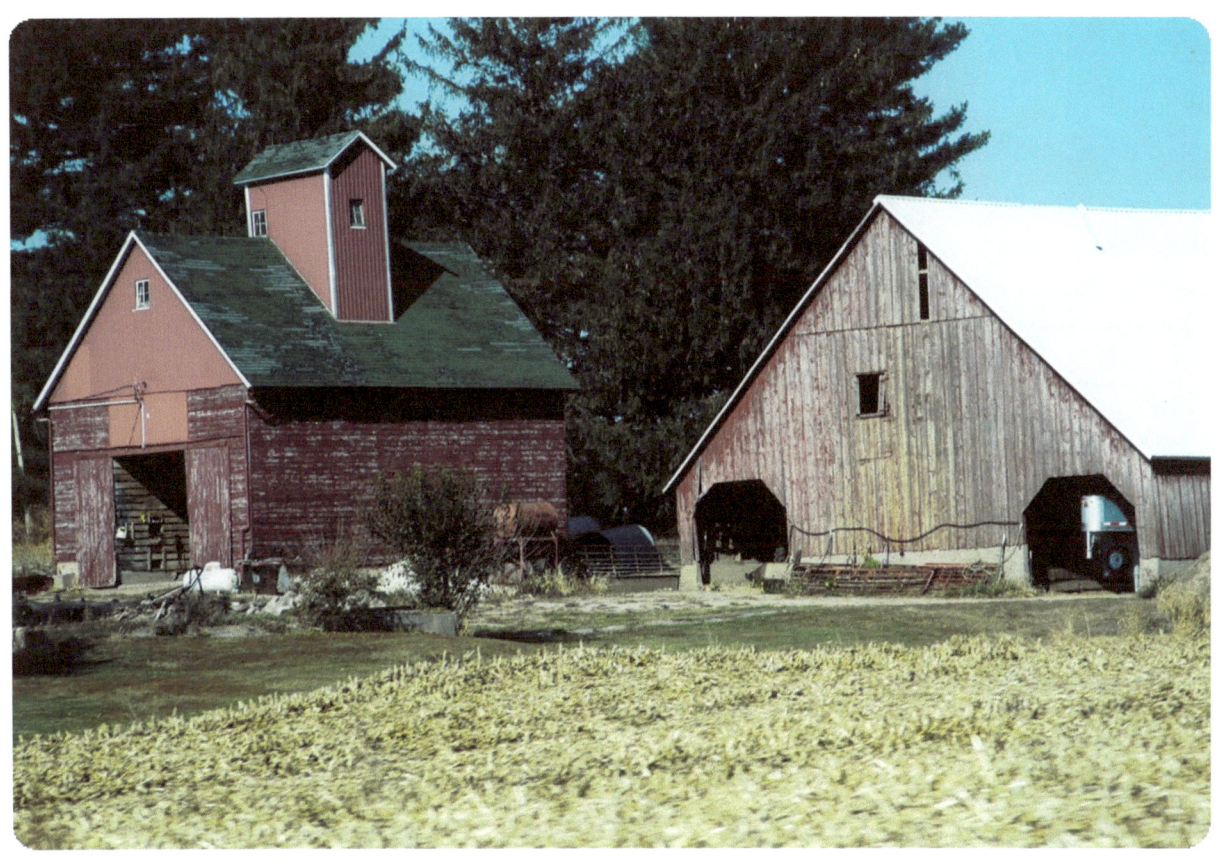

NEBRASKA FARM

This barn style is characteristic of the barns built in Iowa and Nebraska. I especially liked the Pigeon coupe on the corn crib /tractor shed.

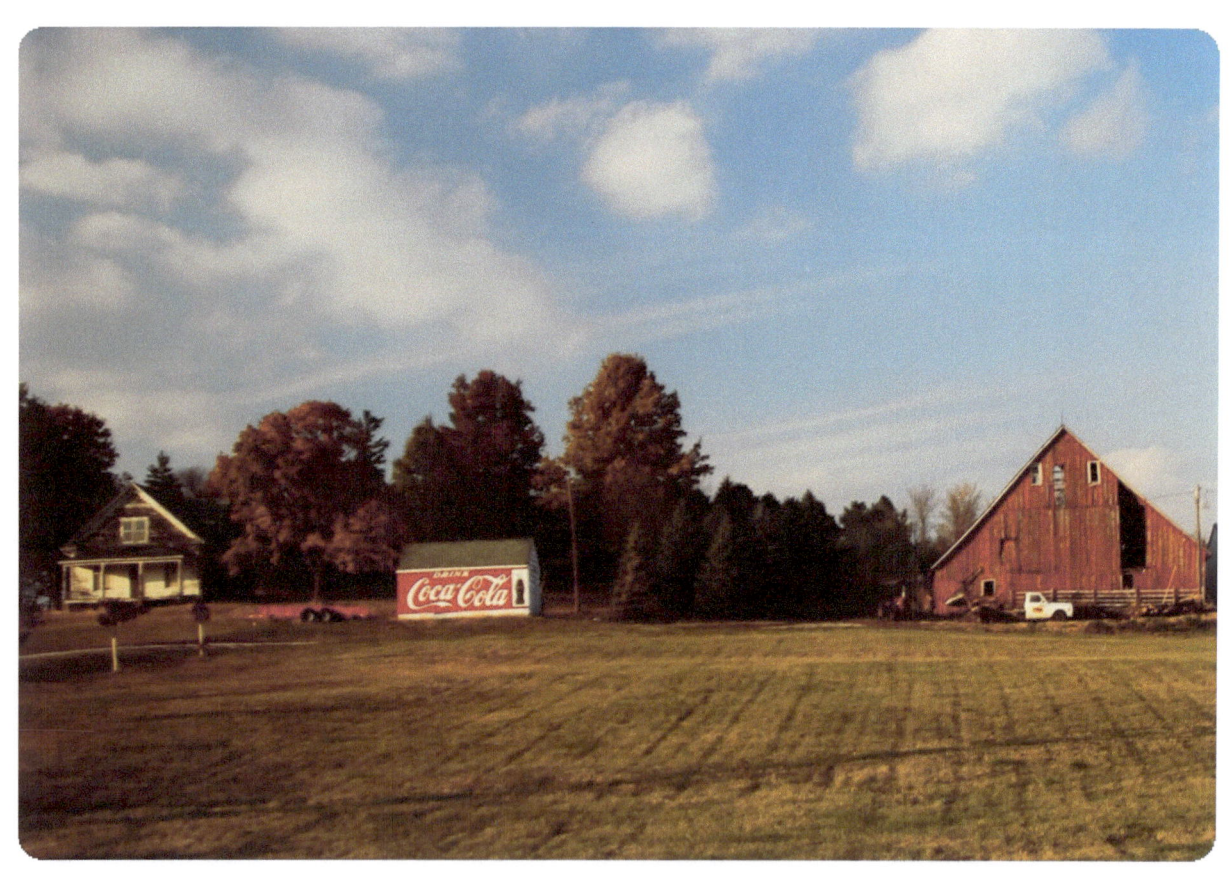

COCA COLA GARAGE

We caught this favorite American icon in Iowa.

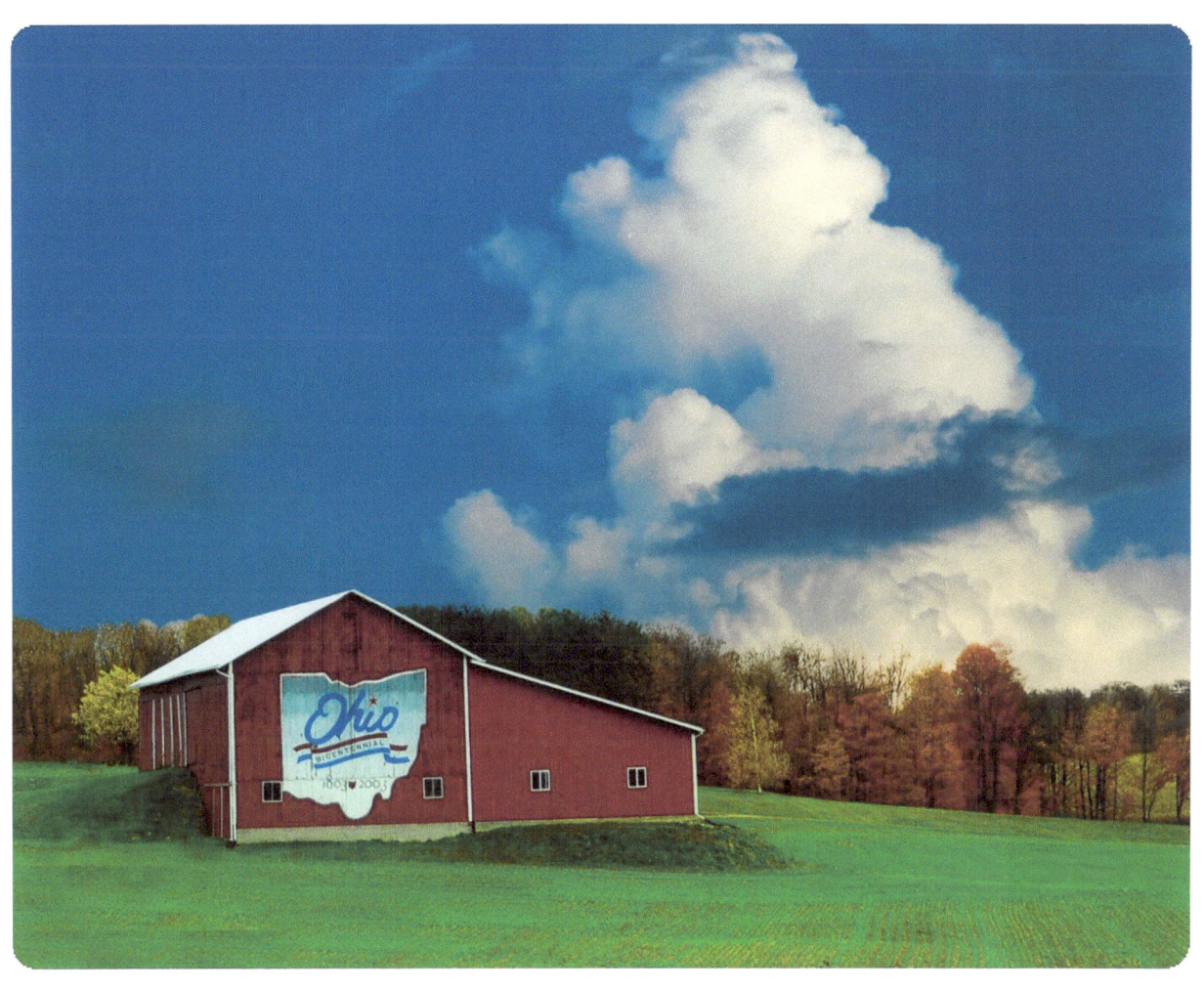

PATRIOTIC BARN

The Patriotic Barn is located along I-70, but I don't remember the exact location.

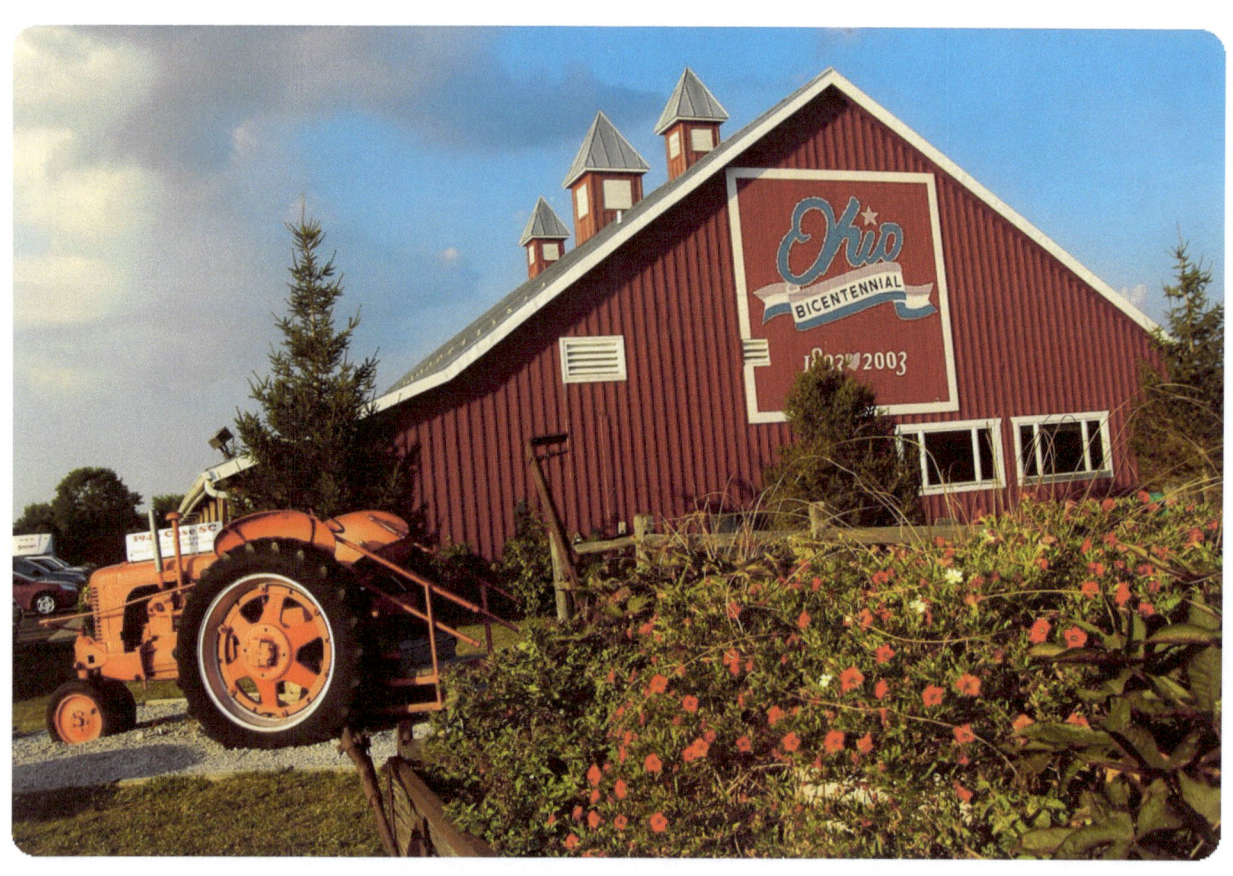

YOUNG'S JERSEY FARM

This old case tractor and the pretty bicentennial barn are located near Springfield, Ohio. It's known as "the Young's Jersey Farm." They serve wonderful ice cream among other things .

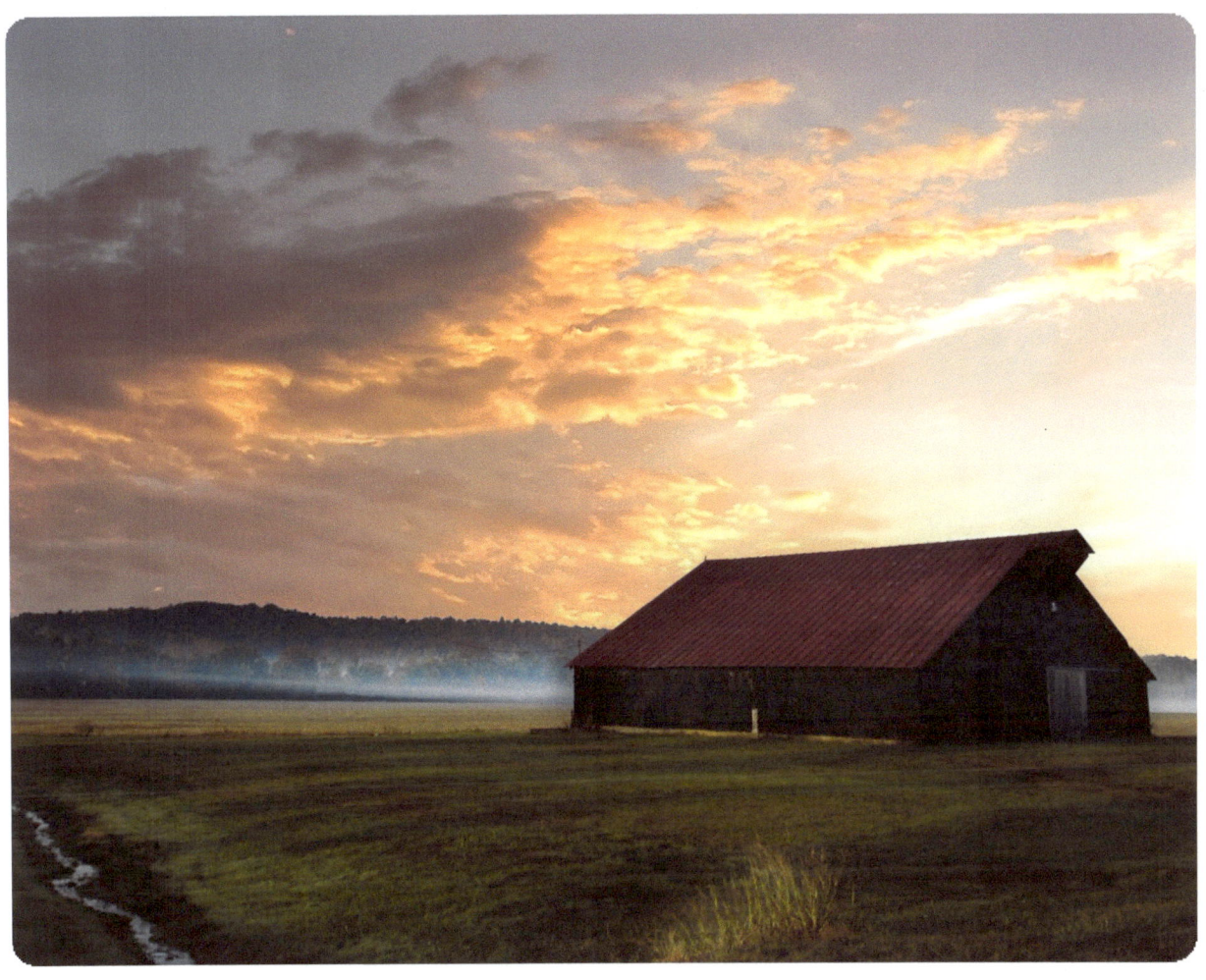

FALLS CREEK ROAD BARN

This nice old barn sets by itself on Falls Creek Rd, Ross County Ohio

The roof extension was necessary for the hay fork hook to extend out beyond the barn and drop down into the wagon of loose hay, which pulled hay back up into the barn. It ran along a metal track all the way to the rear of the barn and dropped the hay at the proper place in the hay mow. If you have never played in a barn filled with loose hay, you missed out on a great part of farm life.

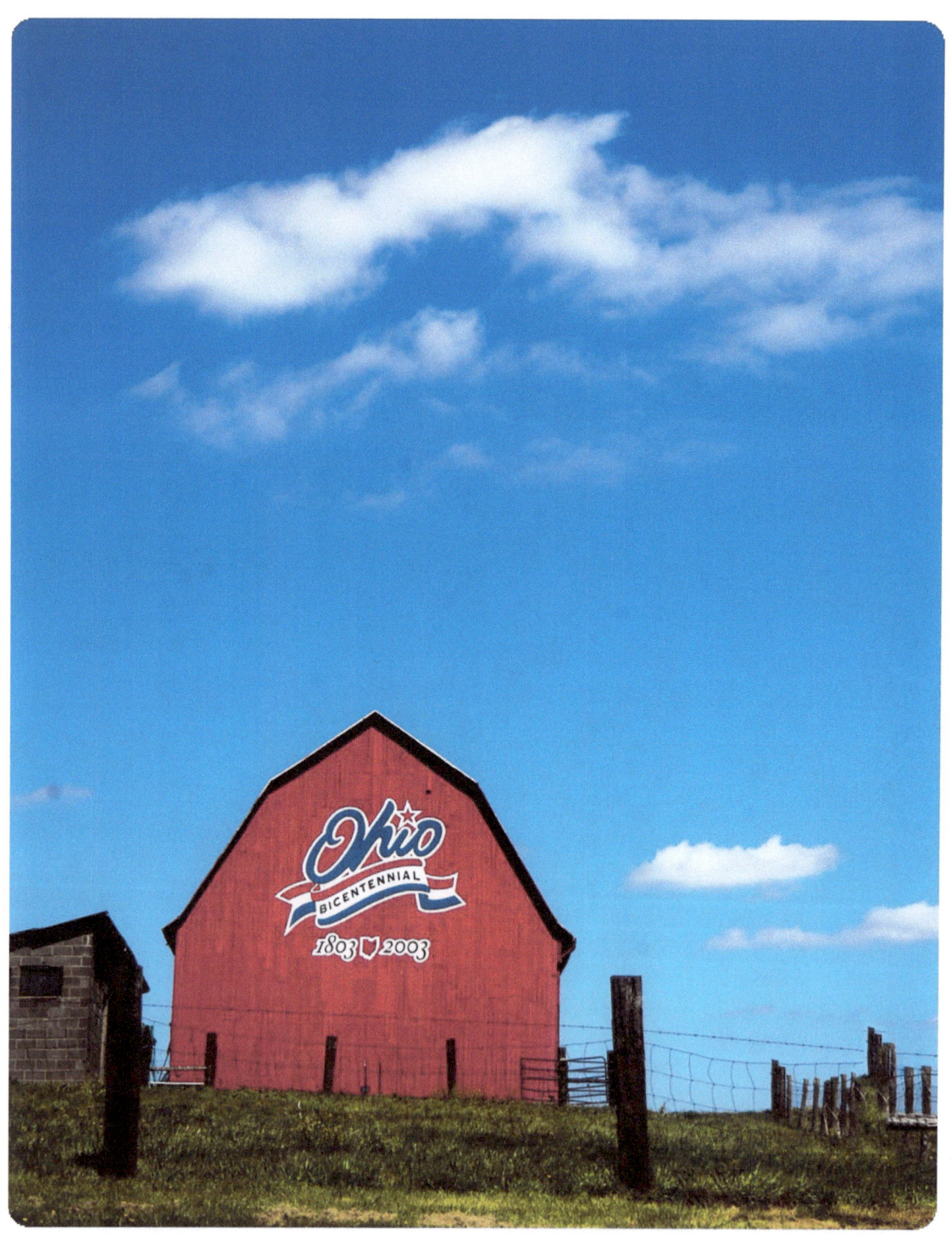

MINFORD, OHIO BARN

Here is another shot of the Minford Ohio barn. I thought the red barn, beautiful blue sky and the white clouds enhanced the patriotic barn painting..

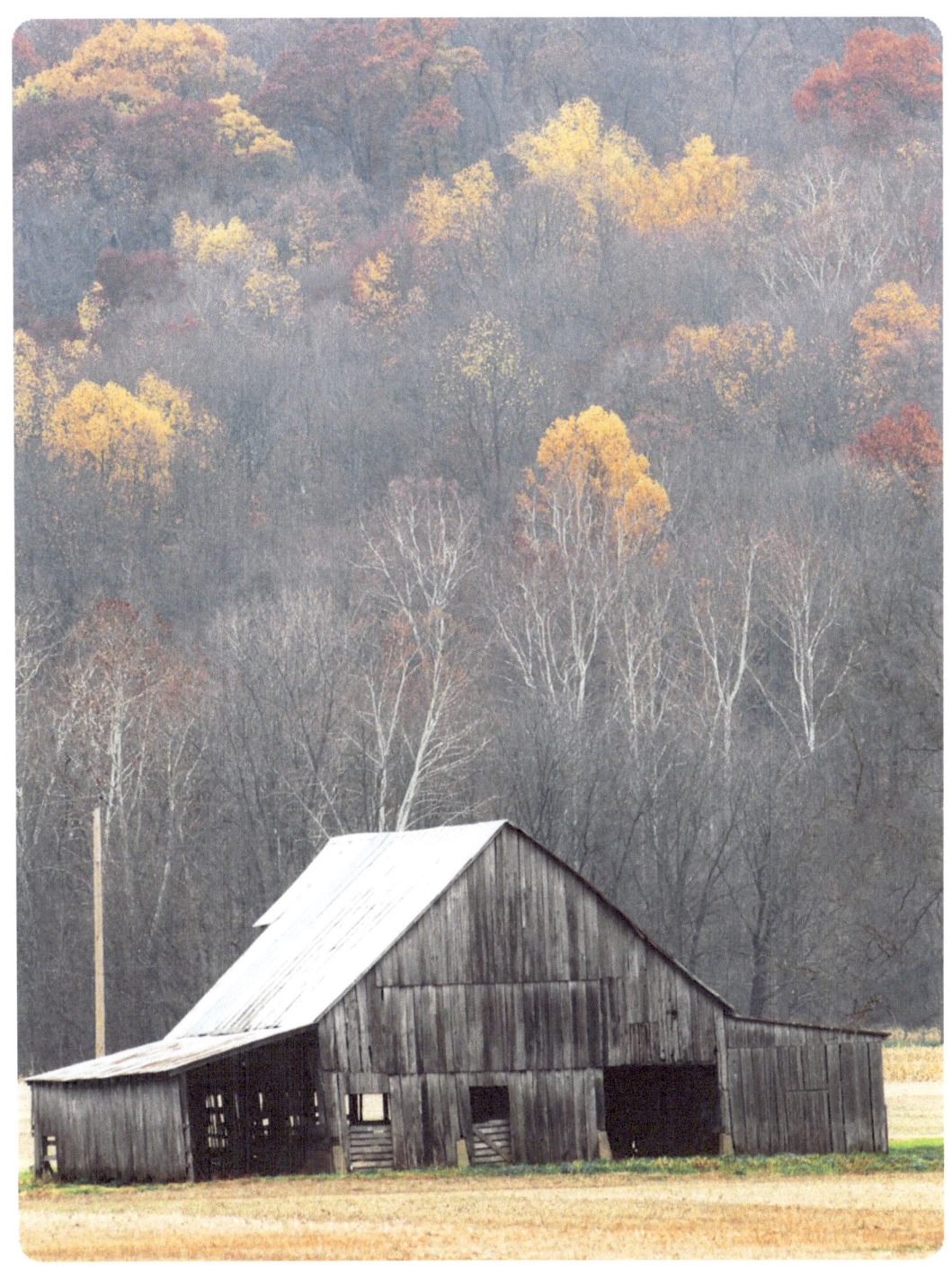

SPARGERSVILLE ROAD BARN

I've captured this old barn several times; even in the dead of night with the stars shinning. it's located on Spargersville Rd near Bainbridge, Ohio.

BLUE ICE CHEW MAIL POUCH BARN

Located near Wilmington, Ohio I captured this on a very cold morning. You can see the icicles glistening in the barn yard, as the rising sun tries to warm things up. I guess the farmer needed more space because he built a lean-to shed over part of the now famous "Chew Mail Pouch Tobacco" signs.

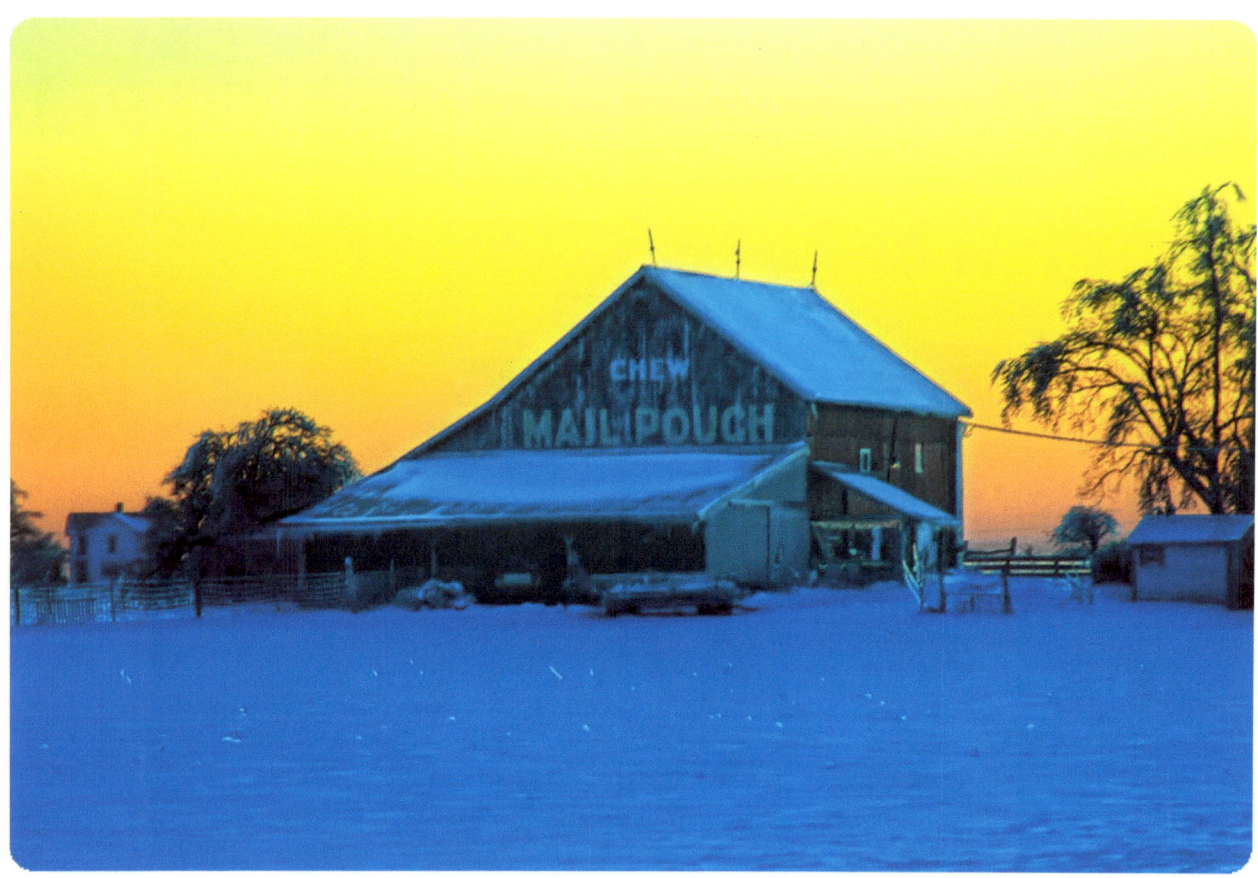

These barns were painted all over the country from 1890 until 1992 by various painters. The last known painter was Harley Warrick. Tobacco finally went out of favor and so did the painting of our wonderful old barns built of wood.

JAG IN THE WINTER BARN

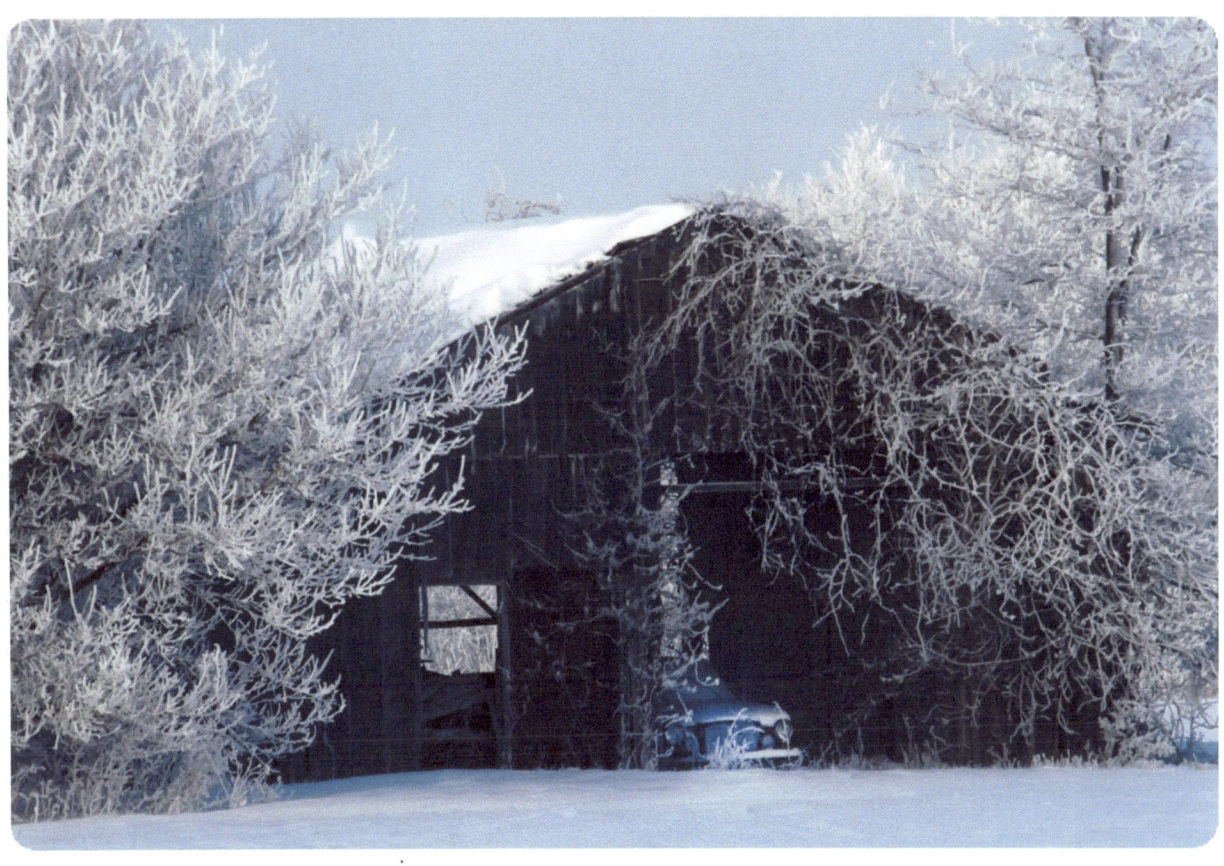

The Jaguar you see in this old barn stayed there for a long time. I photographed this scene many times until they finally removed it and demolished everything. I don't know what happened to the Jag, but I had a lot of fun photographing it over the years. This was located on National Highway 40 just west of Cambridge City Indiana.

BLACK CHEW MAIL POUCH BARN

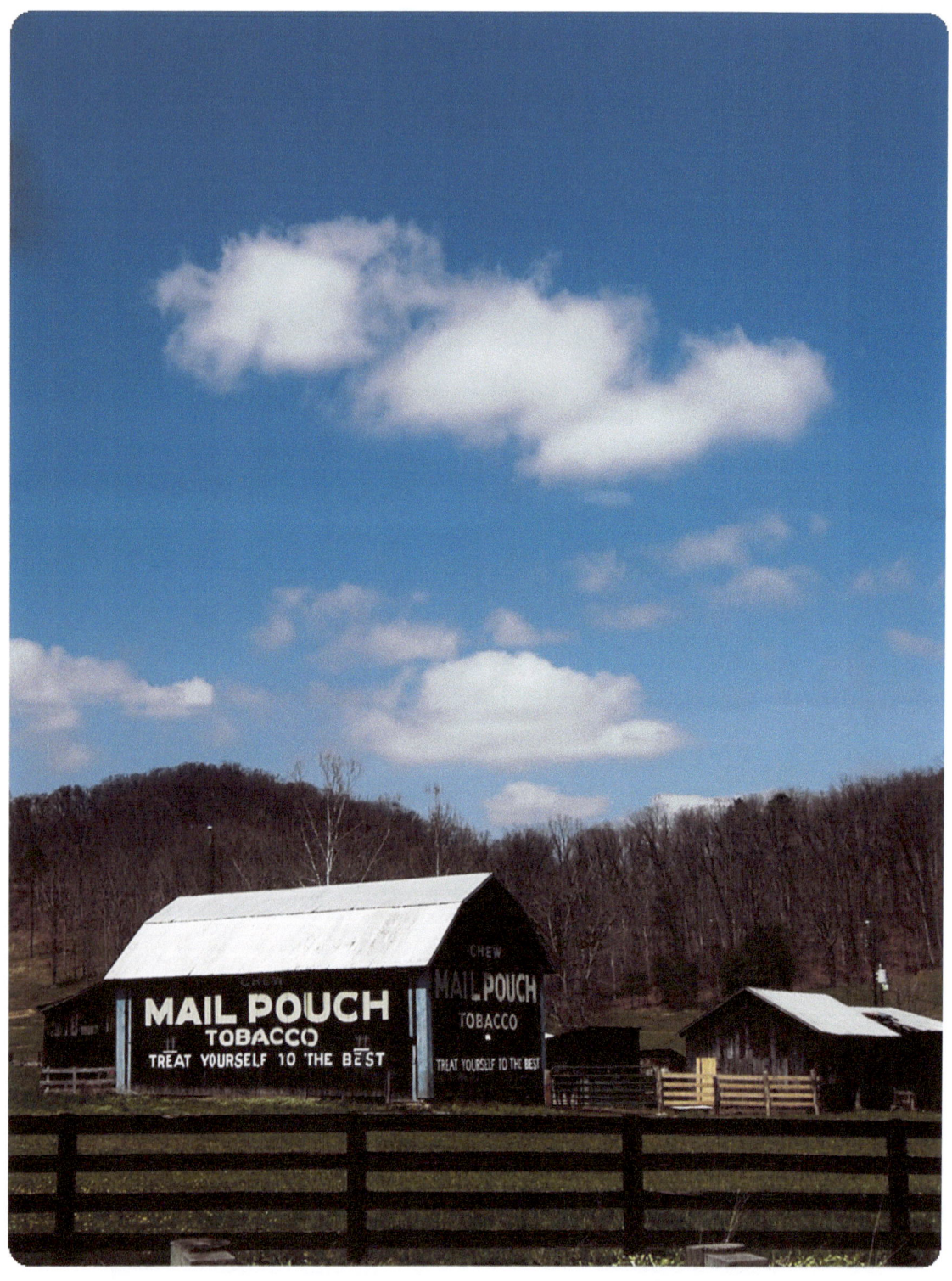

Located in Scioto County on Route 73, just west of 104, this barn has been kept is shape.

GERMAN RED TRIM BARN

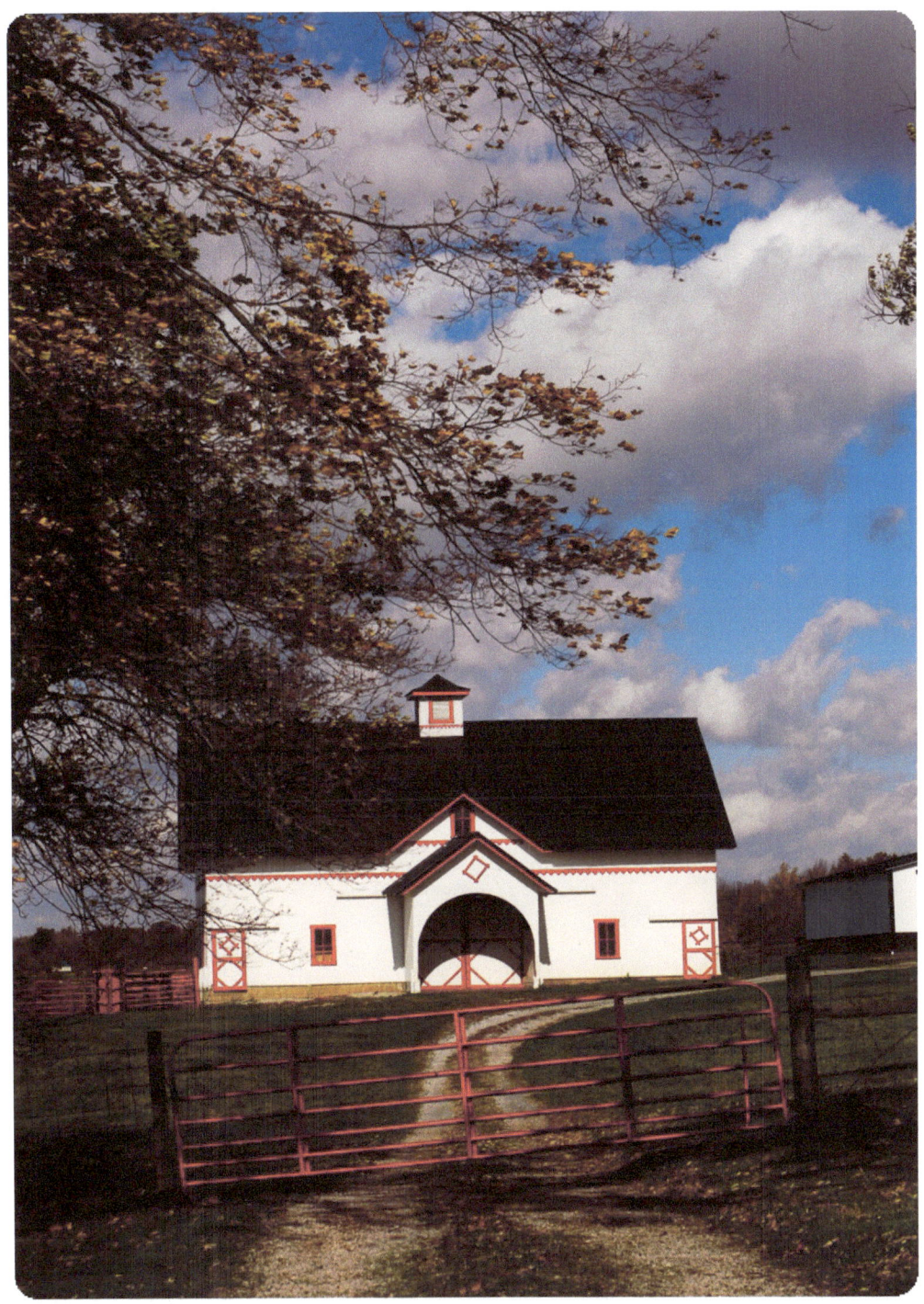

One of the prettiest barns in several counties, this one is located on Rt. 50 just east of Hillsboro, Ohio.

SUNSET IN BARN DRIVE THROUGH

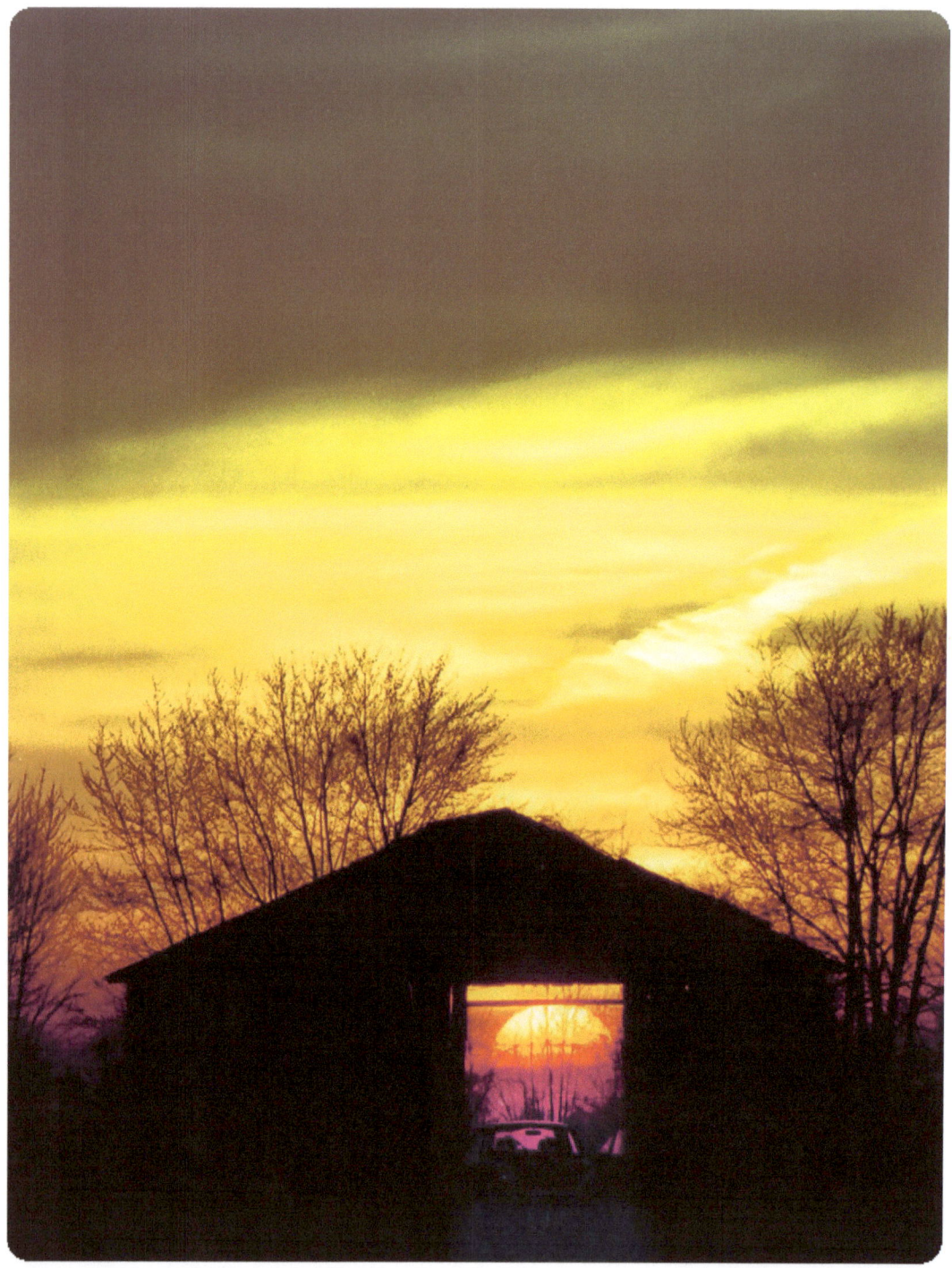

Here is a rare shot of the sun passing through the barn enveloping the old Jaguar. This only happens on July 27th and I happened to be there. Located on Rt. 40 In Indiana.

BARN WITH LONG LANE

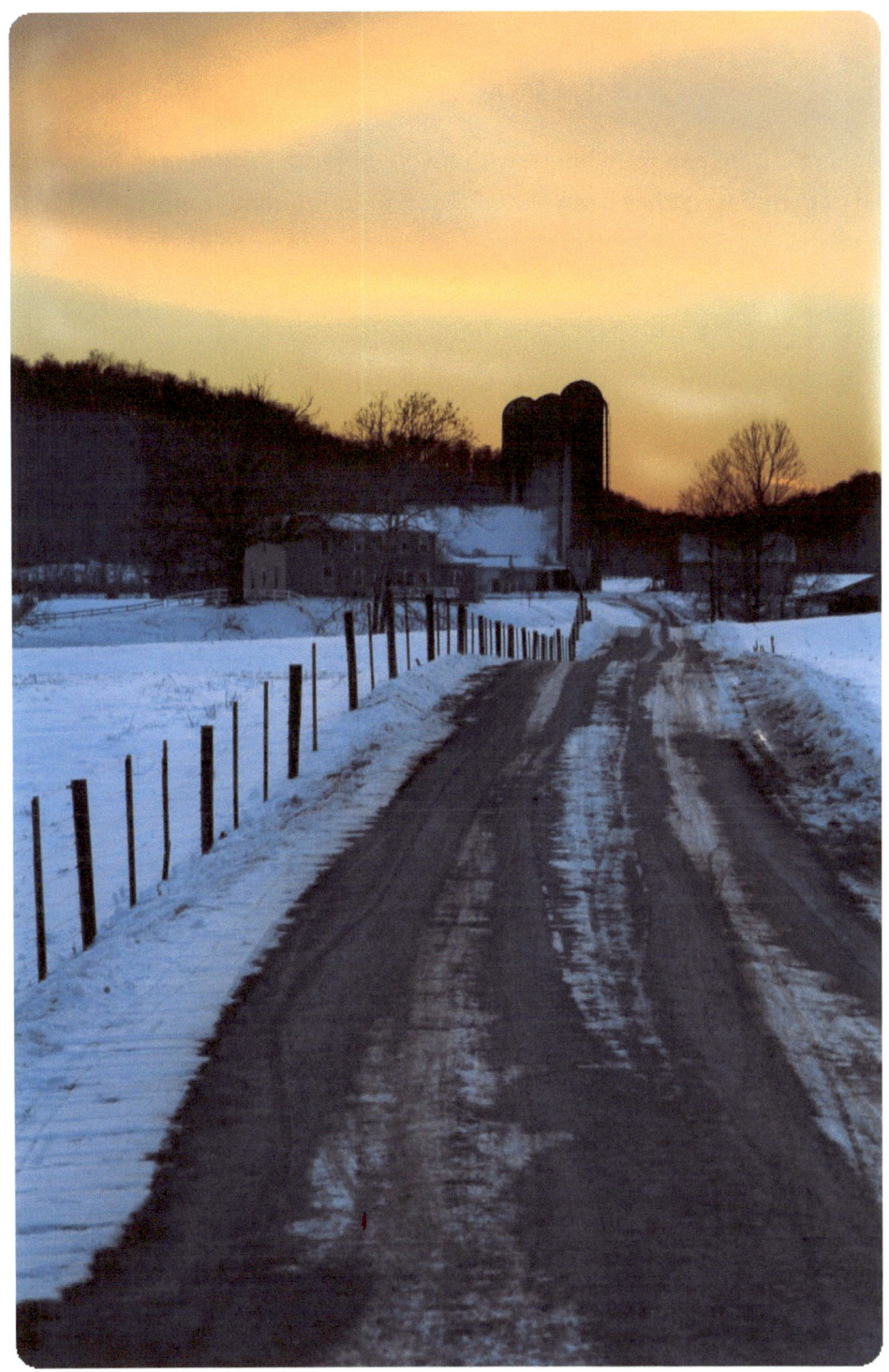

This is a long lane to walk in the cold of winter. It is located in Pike County Ohio.

FARM SILOUETTE SUNSET

The siloutte of this old barn and farm house with the setting sun just seemed to go together; both at the end of their day. It has been abandonded for quite some time, but you can tell it was a money maker in its day. It is located on Rt. 41, a very scenic road, between Greenfield and Bainbridge, Ohio.

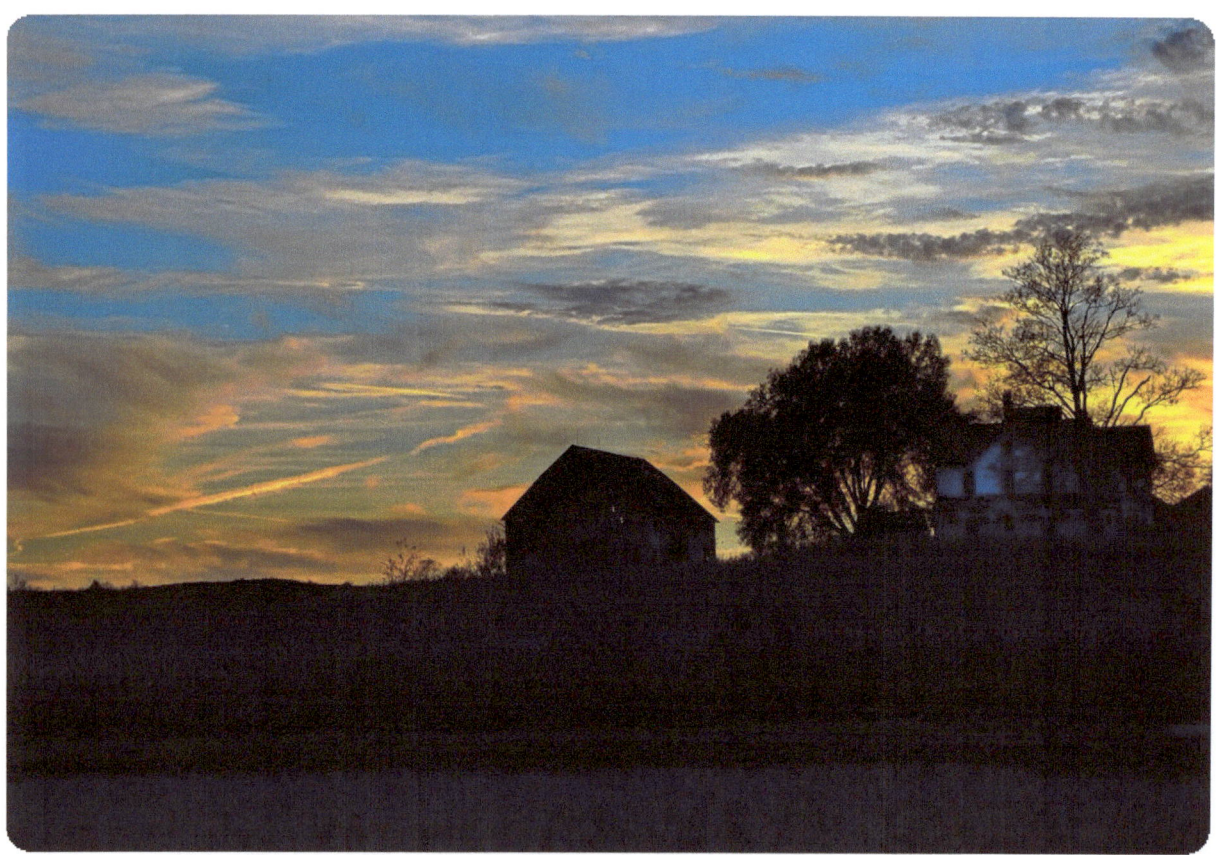

The soybean fields all around are still being farmed, but probably by someone other than the original farmer.

GOLDEN SUNSET SURROUNDING BARN

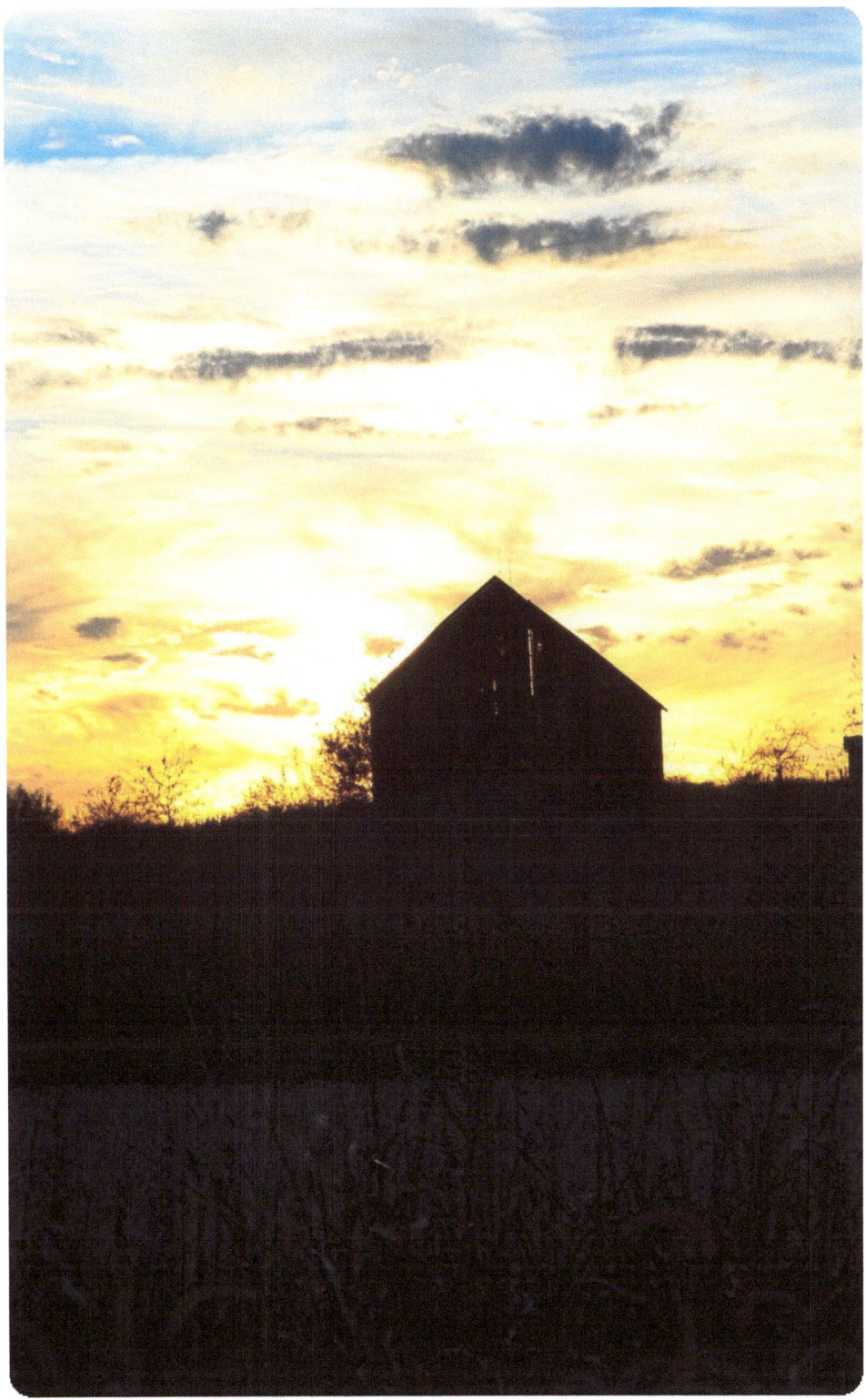

The golden hues remind me of butterscotch ice cream. The barn was a bonus.

This was such a great sunset I thought I would include it.

God's creation never ceases to amaze me.

SLEEPY OLE' BARN

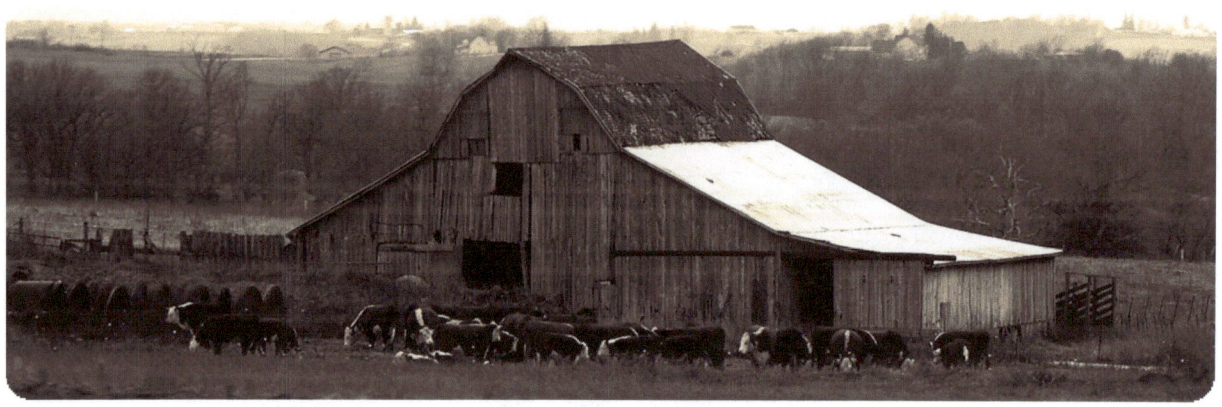

While traveling up in Wisconsin, we drove past this scene with the barn, cattle and farm houses in the background. I thought the barn looked like it was yawning.

I had to use a telephoto lens and then crop out the foreground distractions to capture what I felt would make a good composition.

I titled this "the sleepy ole' Barn" spreading her wings to care for the cattle.

THE OLE' RANCH

Here is another old barn that's no longer there. This one was on Paint Creek just off Rt. 50 at "the Point" in Highland County next to Ross Co. line.

I couldn't help but notice when processing this image how the tree line resembled the barn roof, only reversed.

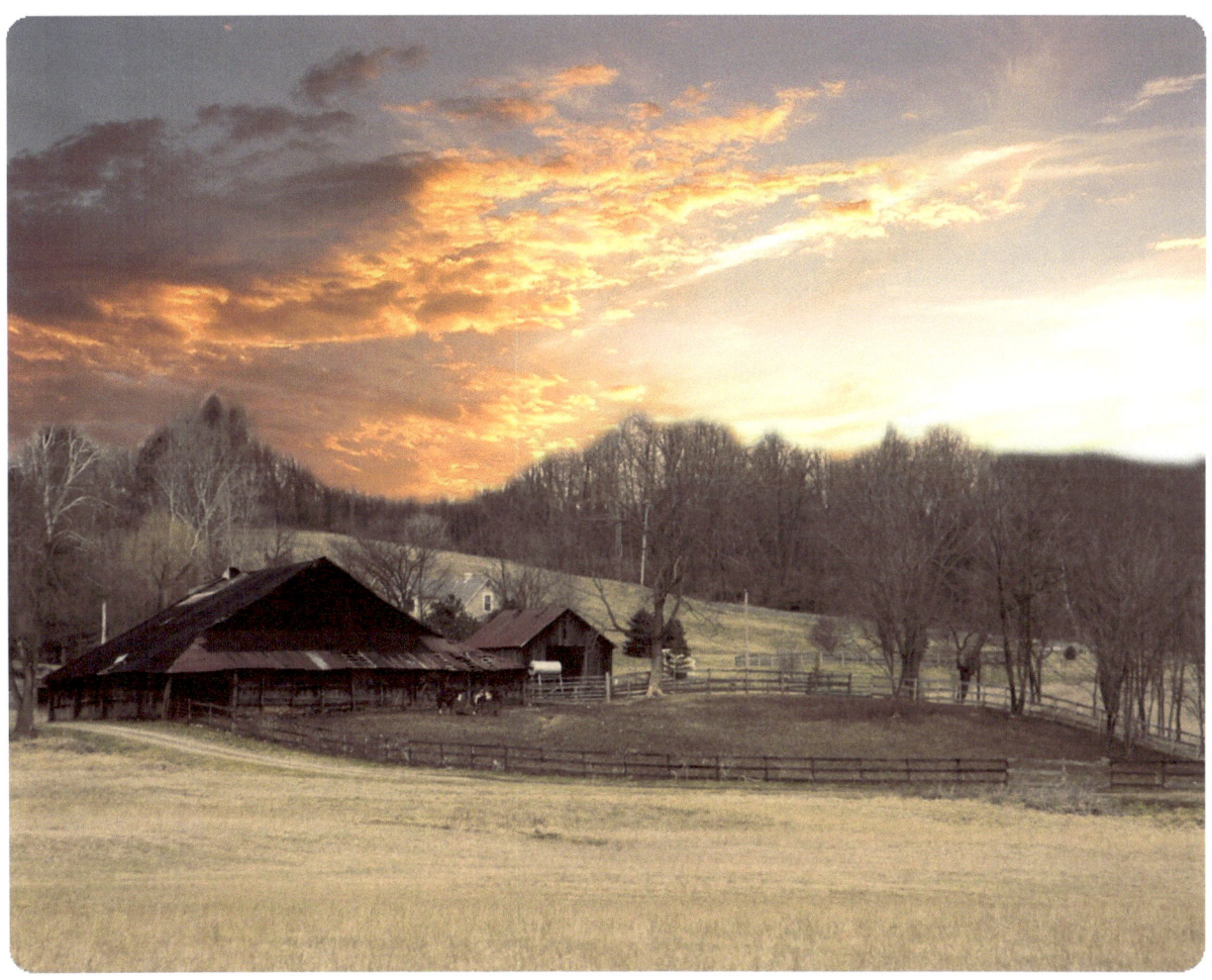

HOAR FROST BARN

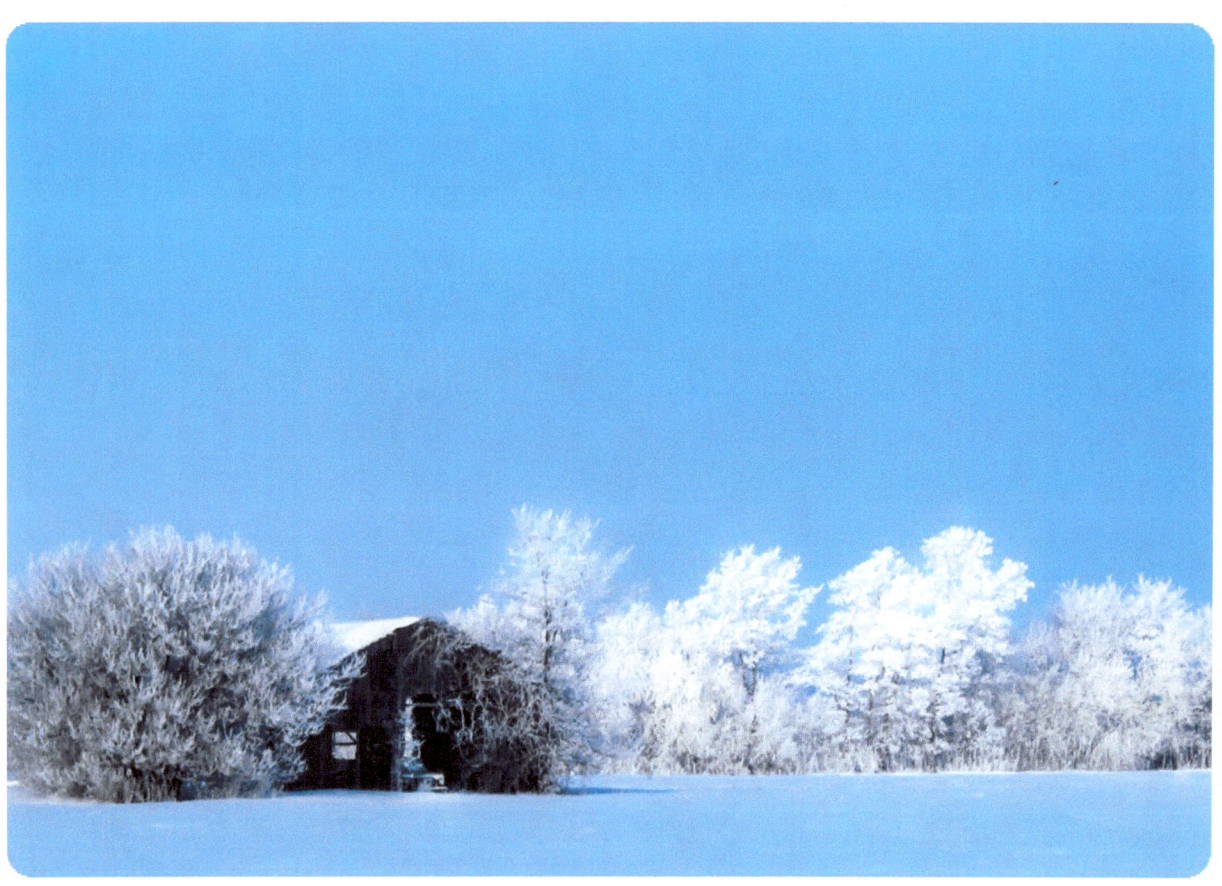

This was a time of hoar frost and snow, when finally the sun came out and lit up the trees, looking like a giant flash went off.

NOTORIOUS RED BARN IN THE SMOKY MOUNTAINS

We spent about five months in the Smoky Mountains working and photographing all around. This barn is notorious for its scenic roll in one of Disney's films. It's located just south of Newport near a little town called Cosby. This place is not quite commercialized like Pigeon

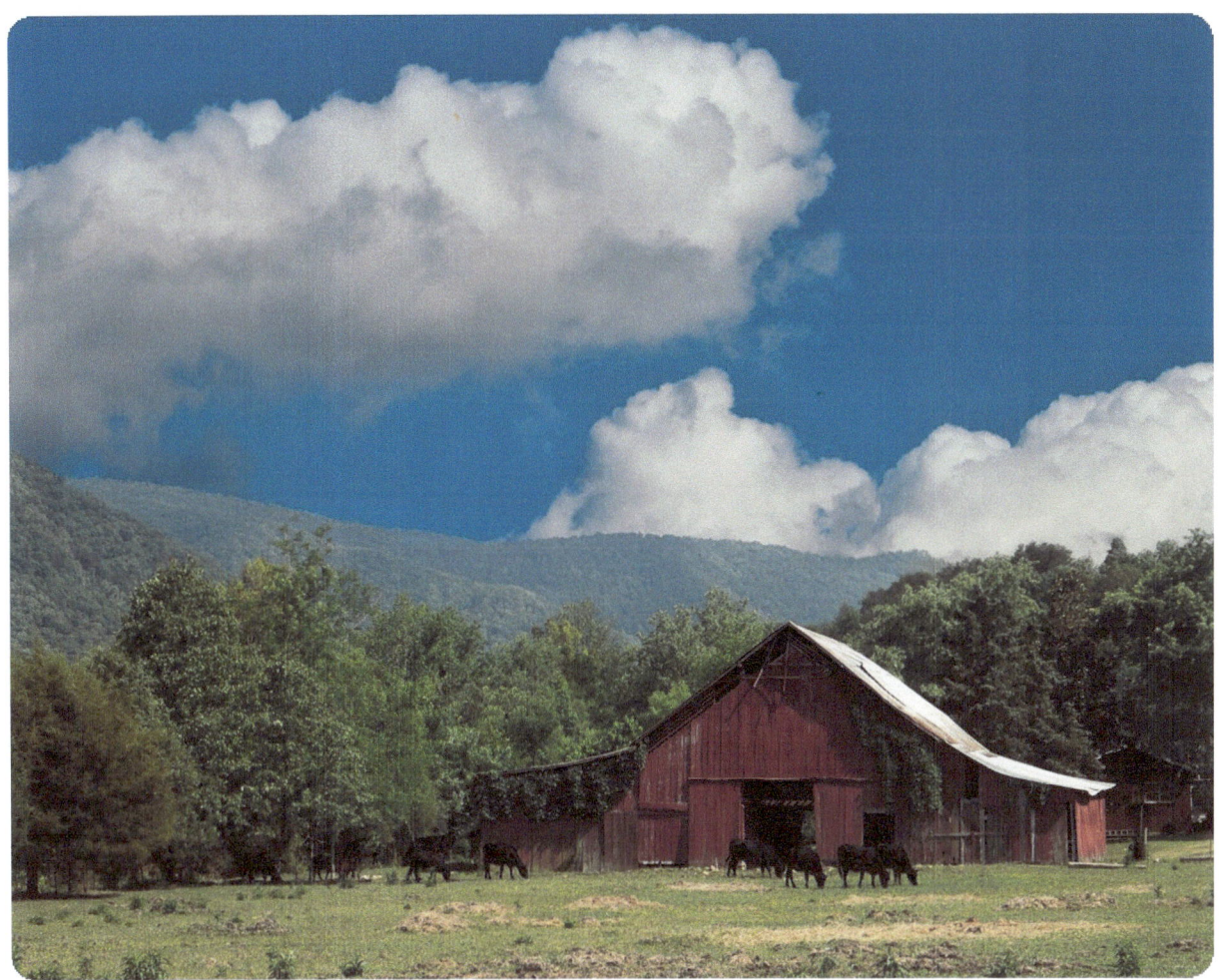

Forge and Gatlinburg and a very nice place to go see.

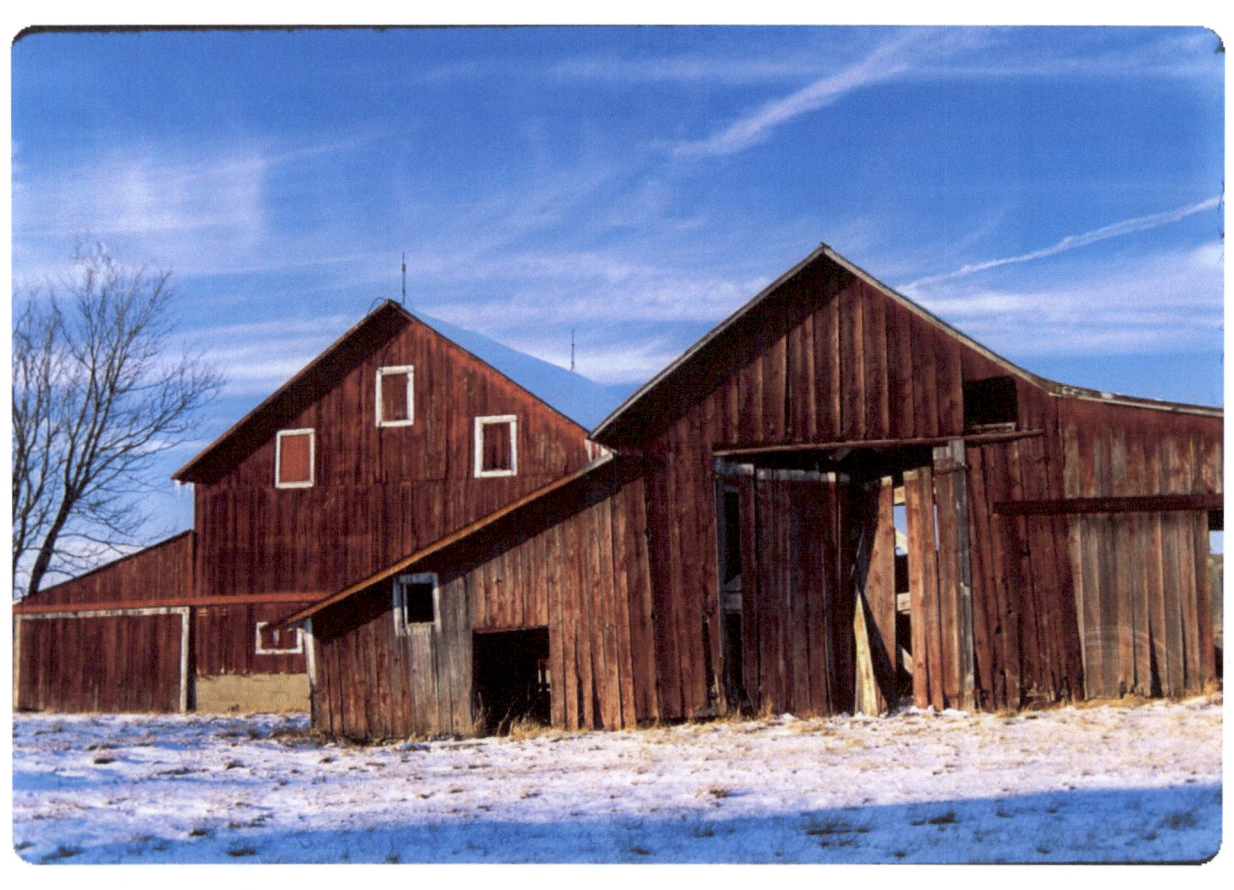

OLD AND THE NEW

They decided they liked the style of this barn, so well, they built a new one almost the same right behind the old barn. Barns are a wonderful place to store and protect things from all the elements, but they do need some upkeep to keep them in shape.

MODIFIED BANK BARN

This is the kind of barn built on a slight bank giving easy access from the bottom ground, level as well as the top to drive into with your machinery. This is a very practical style of barn.

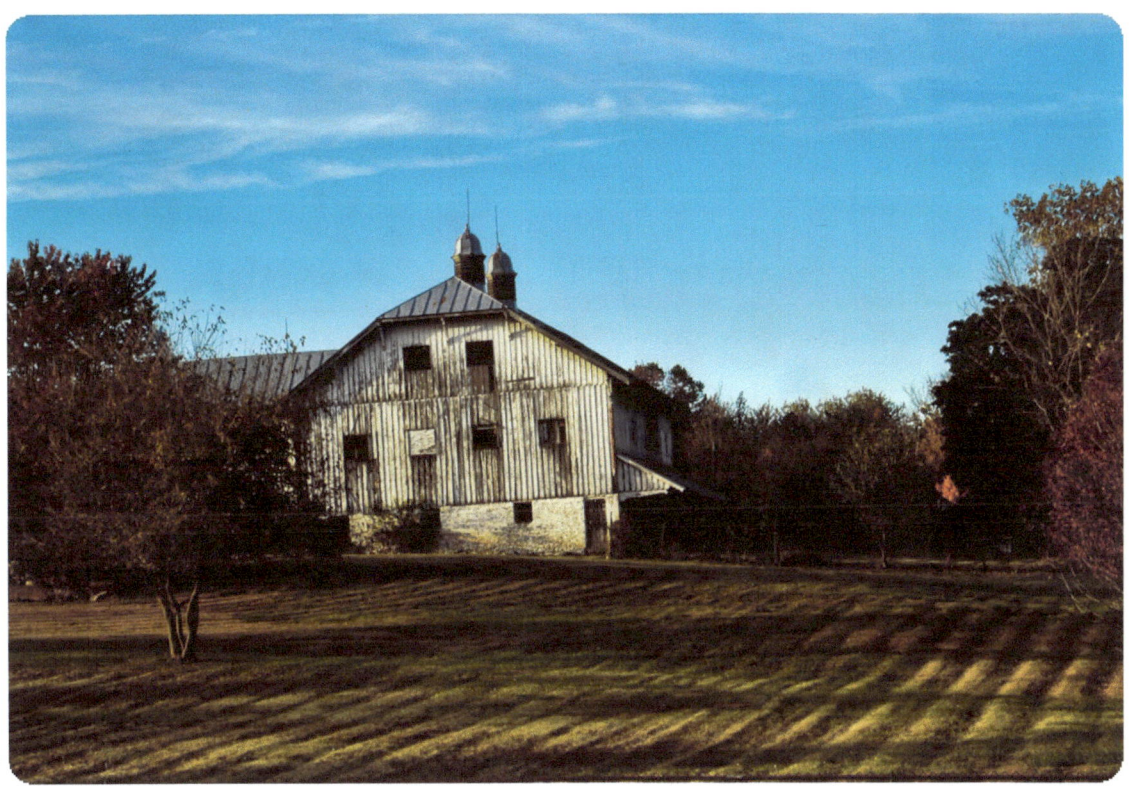

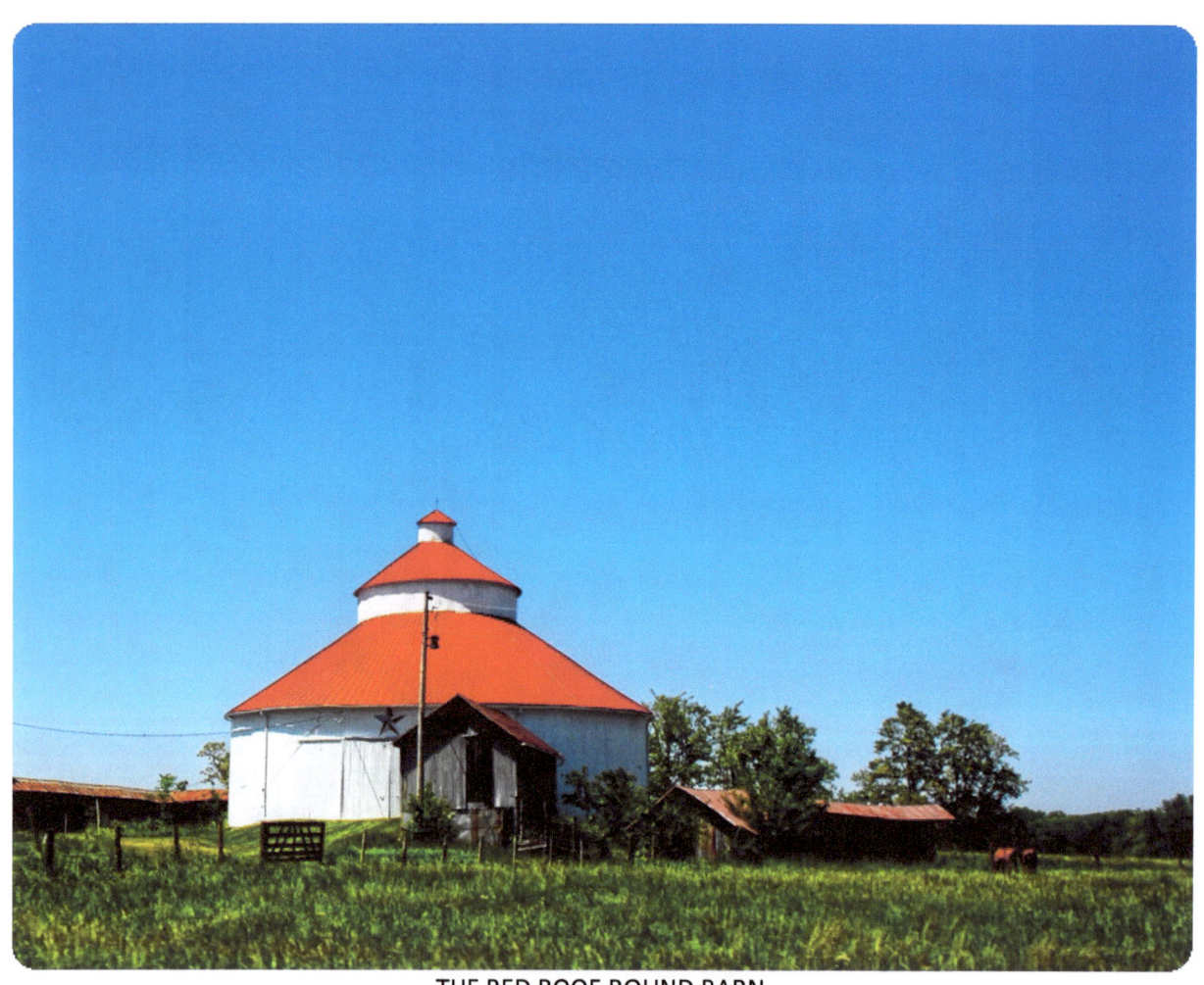

THE RED ROOF ROUND BARN

You can find this round barn up on Route 180 North East Ross County Ohio. Many farmers built this style of barn as a practical and economical means of space.

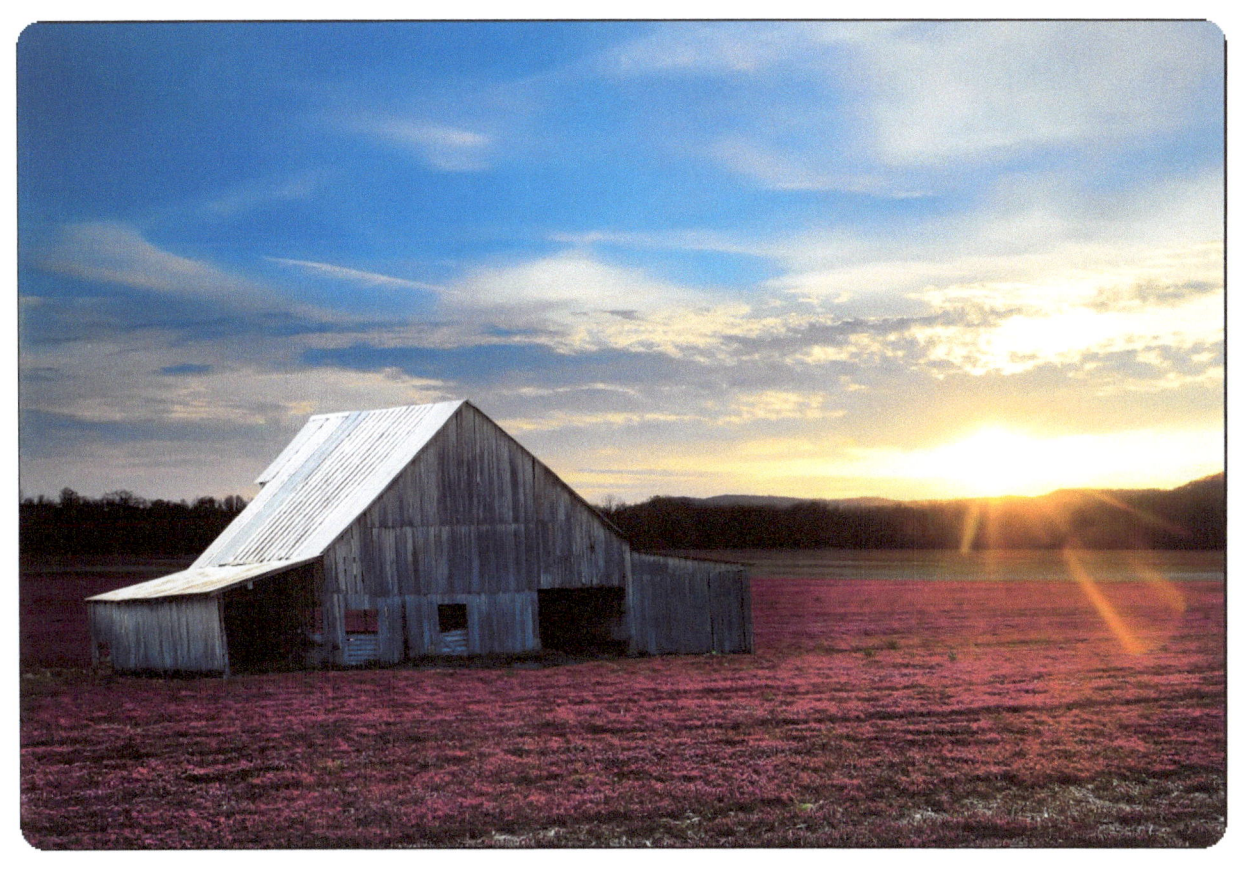

SPRING BRINGS RED GROWTH TO YELLOW SUNSET BARN

I love this old barn. Its style is very common with double lean to sheds on either side. I have photographed this barn hundreds of times to catch the shots I wanted. This particular shot is from the rear in order to catch the field of wild flowers and the sunset.

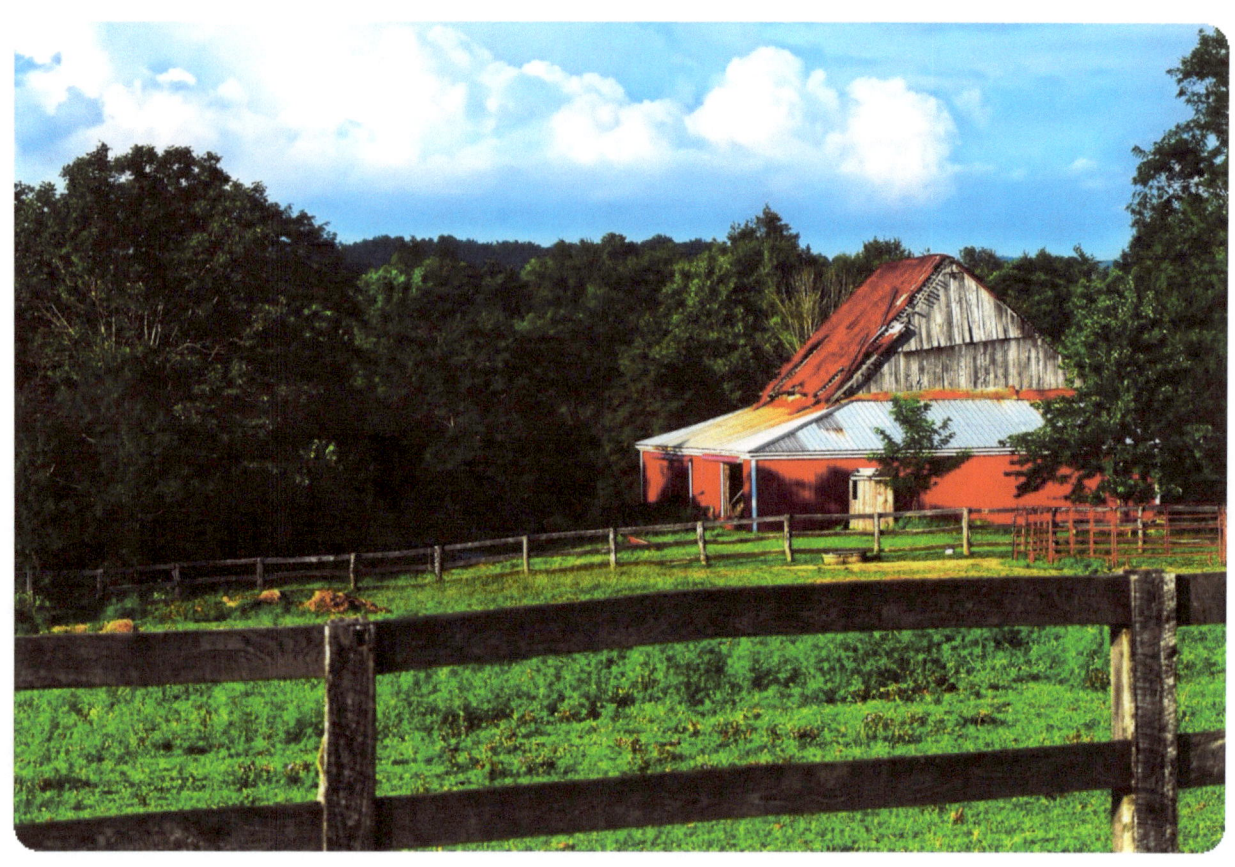

THE BARN AND CORRAL

This old barn and corral is located in Highland County just south of Marshall, Ohio. Just one of the little towns around that used to have their own school and gymnasium. We would play basketball in all these little towns to see who would get to go to the big tournament up in Wilmington.

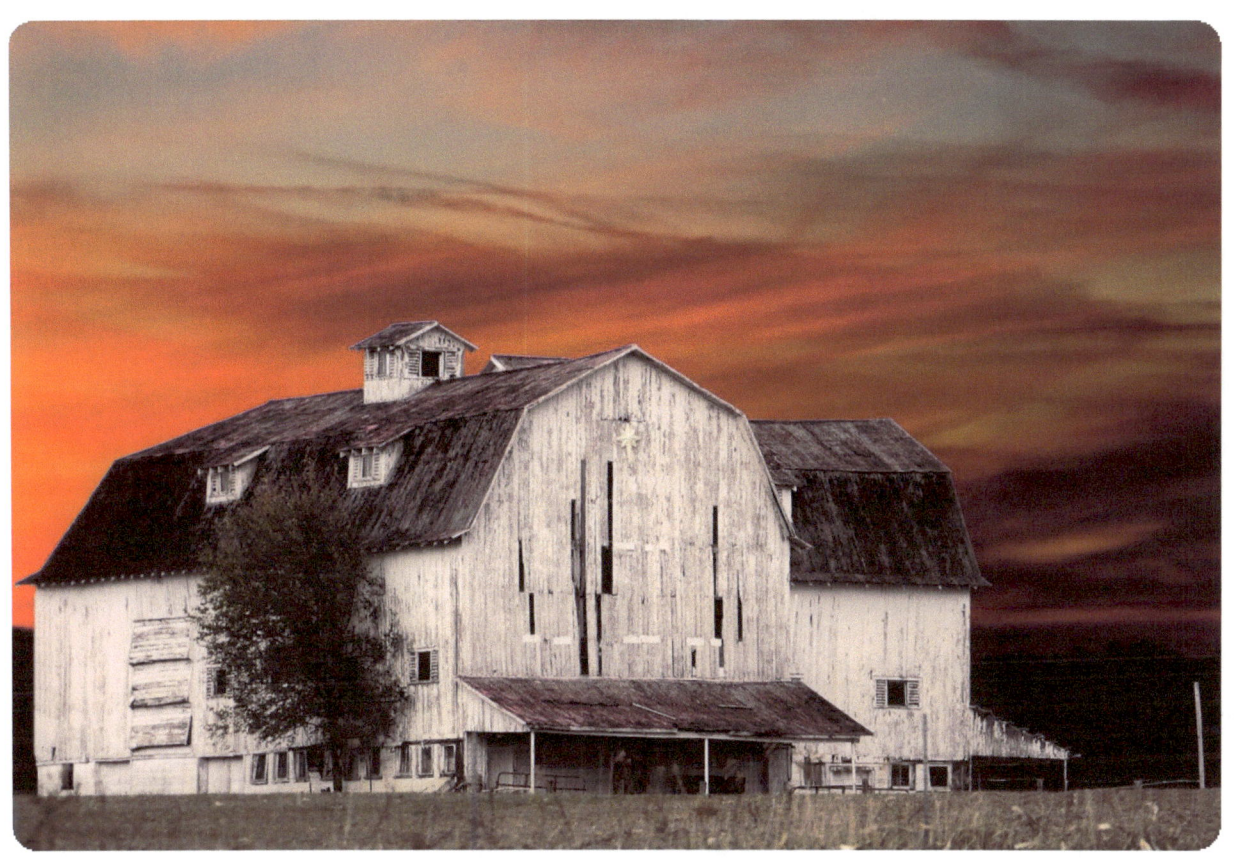

BIG BARN WITH BIG RED SKY

This is a very large barn located on state Route 35 between Dayton and Washington Court House. You had to do some serious farming to build a barn of this size. In that part of the country, they had some of the best soil around; which would grow the best corn and grain anywhere in Ohio.

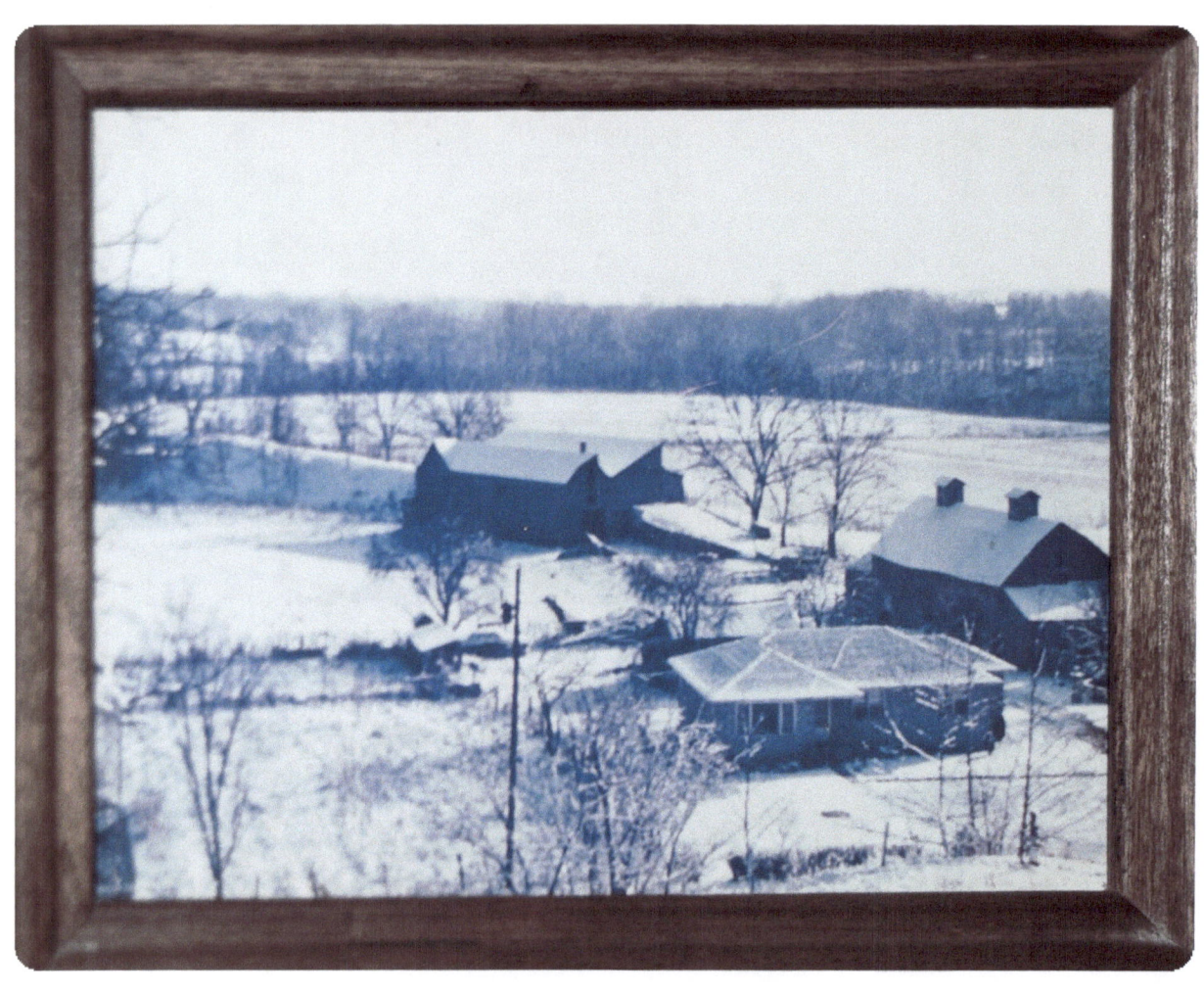

BRANHAM FARM BRIDGES, OHIO

This is a picture taken by my oldest brother Darius that now belongs to my youngest brother Tim. I photographed this snapshot of our old homestead to show where I grew up on the farm. I played basketball in the winter until my fingers almost froze. Farms are a great place to be raised. There are so many things to do from sledding on the hills, to fishing and swimming in the creeks. I love farms and all the old barns..

www.ingramcontent.com/pod-product-compliance
Lightning Source LLC
Chambersburg PA
CBHW051111180526
45172CB00002B/858